Wedding
Photography

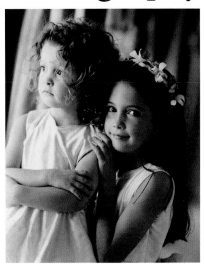

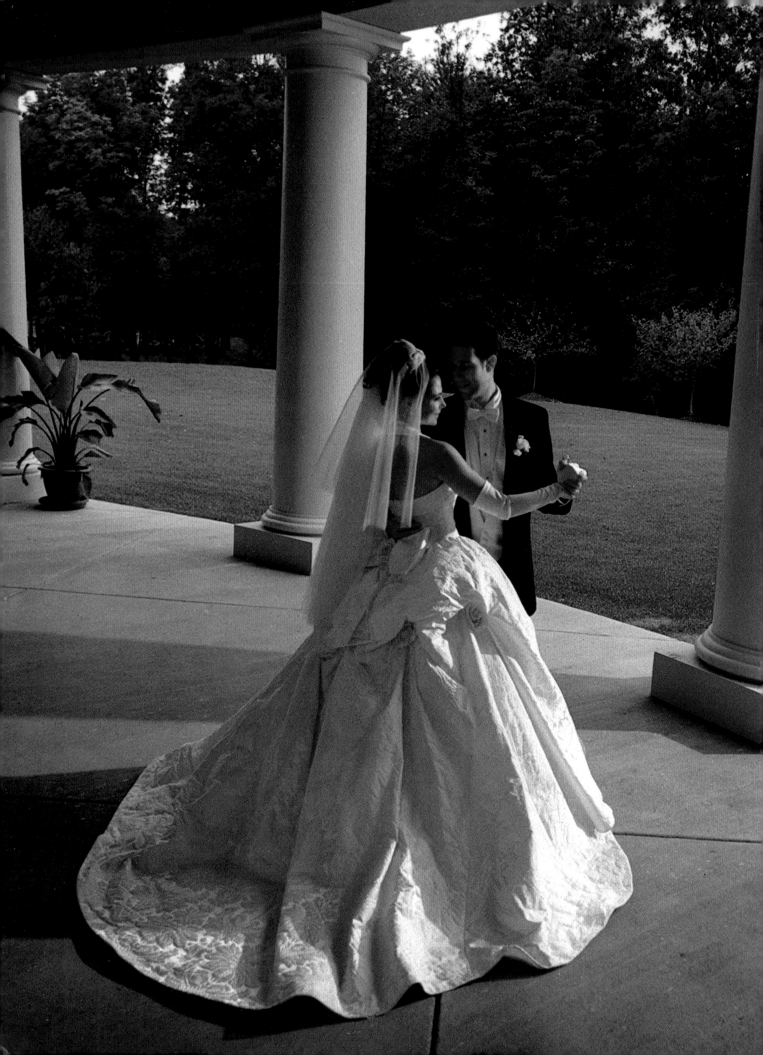

Wedding Photography

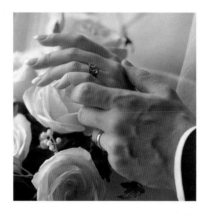

Getting perfect results every time

IAN GEE

COLLINS & BROWN

for Rosemary

First published in Great Britain in 2001
by Collins & Brown Limited
London House
Great Eastern Wharf
Parkgate Road
London SW11 4NQ

Distributed in the United States and Canada by Sterling Publishing Co.,
387 Park Avenue South, New York, NY 10016, USA

1 3 5 7 9 8 6 4 2

British Library Cataloguing-in-Publication Data:
A catalogue record for this book is available from the British Library.

ISBN 1 85585 810 X
Commissioning editor: Sarah Hoggett
In-house editor: Emma Baxter
Copy-editor: John Miles
Designer: Roger Daniels
Illustrations: Kate Simunek

Reproduction by Global Colour Ltd, Malaysia
Printed and bound in China by L-Rex Printing Co.

Contents

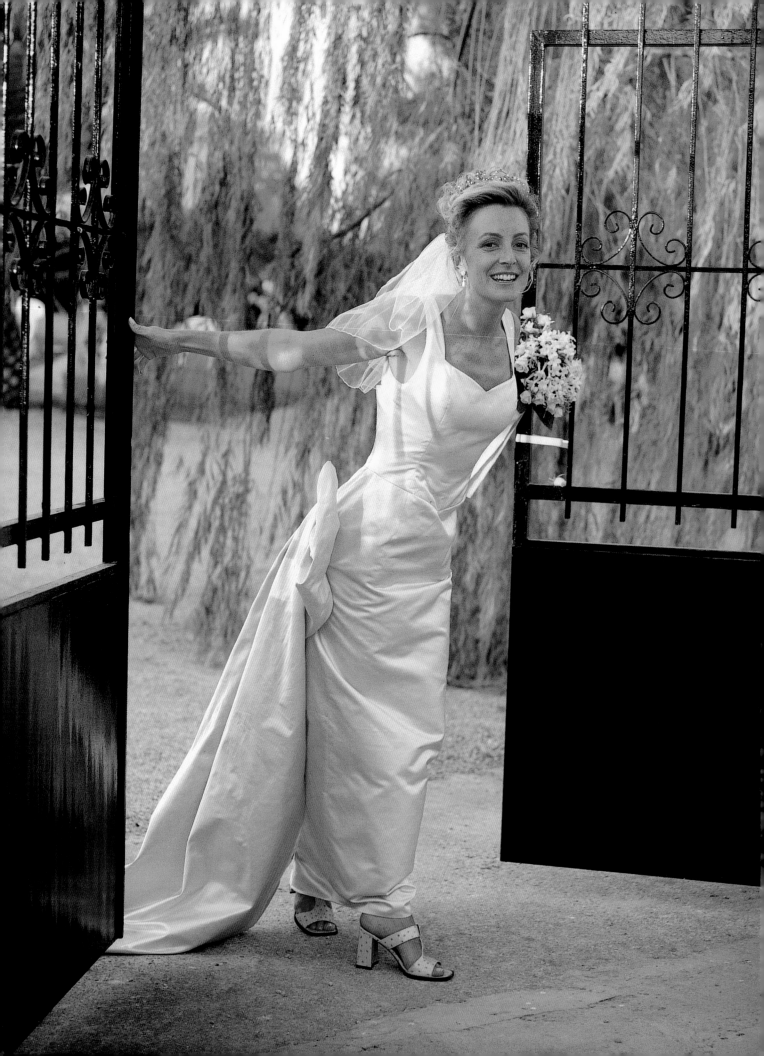

Introduction

Weddings have been photographed since the earliest days of photography, more than 160 years ago. Early wedding pictures were often stiffly posed and depicted the bride and groom only, but then group pictures were introduced. By 1900 some superbly arranged family wedding groups were being photographed with every person individually posed and every face in focus. The photographs were rather expressionless – because of the need to remain still for long time exposures.

In the 1960s the introduction of colour to wedding photographs led to a more relaxed style of photography. But it was not until the end of the twentieth century that the photojournalistic style of photography joined the more traditional posed pictures. This brought along with it a demand for black-and-white images in addition to colour, attractive new ways of displaying photographs and the creative opportunities made possible by digital imaging. With all of these developments, it is no wonder that many advertising and press photographers, who used to view wedding photography as a less creative field, are now joining the ranks of wedding photographers with growing enthusiasm.

An exciting responsibility

There has never been a more exciting time to be a wedding photographer. No other photographic subject is more demanding because of the variety of types of photography required within a limited time period. At the same time, there is great responsibility on the photographer, partly because the couple getting married and their families have made a major financial investment, and also because it is a one-off event and should anything go wrong with the photography, the situation is irretrievable. A modern wedding photographer therefore requires many different photographic skills, calm nerves, clear thinking and good organization.

Facing page and above: Contemporary shots
Modern wedding photography encompasses a wide range of styles – illustrative, fashion, classic portraits and photojournalism.

Recording the events at a wedding not just competently, but excellently, is not for the inexperienced – and yet you cannot get true experience of wedding photography other than by doing it. You can practise taking a few photographs of a couple, but without the pressure of time on the actual wedding day you cannot reproduce the conditions in which you will be working at a real-life event.

The aim of this book is to provide you with some of the tools necessary to become a wedding photographer. To take on the responsibility of a wedding without a lot of knowledge and at least some experience could lead to a very disappointed family and even perhaps ruin a friendship. By fully preparing yourself in advance you can acquire the competence, confidence and imagination to perfectly capture the special day.

Part 1

BEFORE THE WEDDING

Photographing a wedding is not simply a matter of turning up at the venue a few minutes before the bride and firing away. Your principal purpose is to produce a storybook of the day. While every wedding follows a basic formula, each is an individual event and different from all others because of the taste and choice of the participants.

A great deal of preparatory work is required: getting to know the couple, their families and their thoughts on how they would like the wedding photographed.

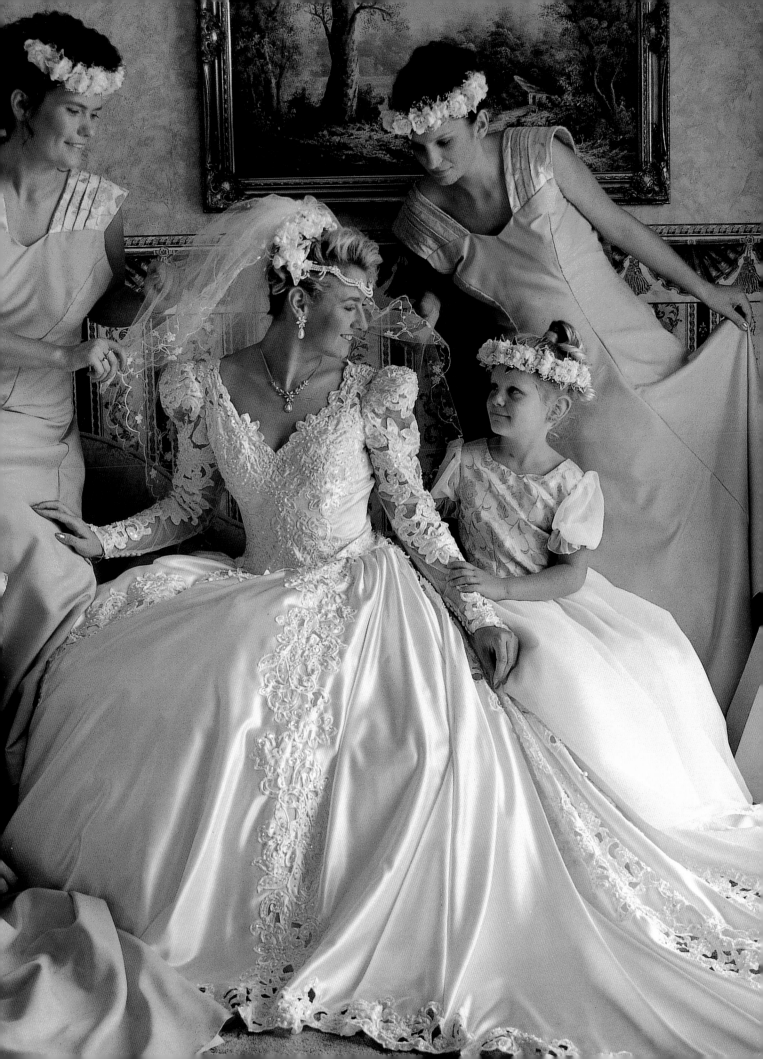

Equipment and technique

Which camera is the the most suitable for wedding photography? The answer has to be one you are completely familiar with, one you can operate by feel without thinking about and one that is going to give you the images you want. A wedding is not the time to experiment with a new purchase.

Which format, 35mm, 120 or digital?

Traditionally most wedding photogrphers have used the 12-on 120 format. There are several reasons for this:

• the square format means you do not waste time considering whether to shoot portrait or landscape, nor physically turning the camera, awkward with a tripod

• interchangeable backs permit rapid change of film type

• the format produces outstanding print quality

• a 120 format camera says 'professional' to clients

35mm cameras benefit from a wider range of lenses and the lack of interchangeable backs is overcome by having two camera bodies. The issue of quality has become minimal with the availability of enhanced films and cleaner laboratory services.

Most serious wedding photographers currently use both formats to cover weddings, colour in the medium format and black and white in the 35mm. Keeping the colour and black and white in separate formats avoids any difference in print quality arising from two colour emulsions in different sizes. If shooting colour in two

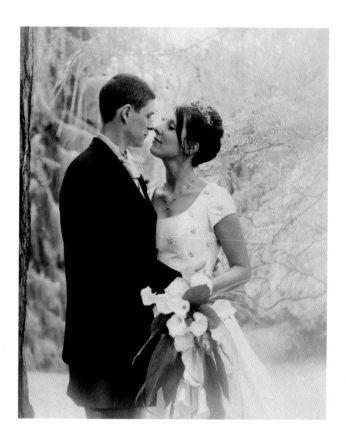

formats use the same type of film in both and you should not notice too much difference.

Some photographers are beginning to use digital cameras for weddings, but film is still a superb medium and furthermore is supported by excellent, inexpensive laboratory services. If you have a leading make of 35mmSLR outfit you will be able to buy a digital body in due course utilising the same lenses.

Tripods

Whichever format you use, a good tripod is a must. A ball-and-socket head is preferable to a pan-and-tilt as one movement takes the place of three. A quick-release bracket is essential if you use the same camera for candid shots.

Getting the composition right

1 Decide where you are going to position the group (or couple), roughly position the camera and check the extent of the background.

Other useful pieces of equipment

■ Incident light exposure meter

■ Reflector

■ Lens hood and filter holder – the best combined unit for wedding photography is Pro-4

■ Low-key vignetter, soft-focus diffuser plus any other filtersof your choice, such as a high-key vignetter and a low-key graduated filter

■ Flash gun and above-lens bracket

■ Polystyrene posing blocks – usually available in a set of four

■ Step ladder for high shots

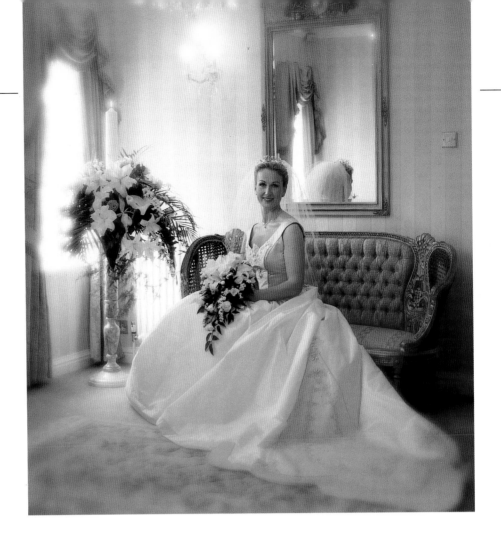

Left: Softening the image
A high-key vignetter produces lighter edges to an image but should not be used when the background is dark.

Right: Using a diffuser
Blur the edges of a photograph with a soft-edge diffuser. Used sparingly, this type of filter helps add a romantic feel to portraits.

2 Leave the camera on its tripod and pose the group. Make final checks of arrangement and check the background for unwanted items.

3 Position the camera and focus carefully. Set the camera position for optimum composition: with a group you need about twice as much space above the heads than you have below the feet.

4 If you have an eye-level pentaprism you will be able to see the whole image through the eyepiece, but if you are using a waist-level viewfinder on a 120-format camera, after focusing through the magnifier, flick the magnifier out of the way, raise your head and compose the image through the whole screen.

5 When you are happy with focus and composition, turn your head and, keeping it near to the lens, talk to your subjects. Look them in the eye and let them see your eyes. Talk clearly, loudly and humorously and build up a repertoire of one-liners that will make everyone smile. As they do, take the picture.

6 You cannot operate in the same way with a hand-held camera, but if you do want to use one, hold the camera within your folded elbow and remove your eyes from the viewfinder to look at your subjects directly as you talk to them.

Watch out for blinks. If you observe any, take another frame immediately.

Film

The best film is colour negative (ISO 160 NPS) made especially for wedding and social photography, as it enables you to capture a full range of tones in both white dresses and dark suits. In poorer light conditions ISO 400 NPH is useful, but a good alternative is ISO 800 NHG II, as it gives you two and a half f-stops more leeway in even poorer lighting conditions. Do not switch from one emulsion to another within the same setting – use the fast film indoors and the slow one outdoors in good weather.

Exposure

Exposure is a major consideration in wedding photography. A couple in a wedding dress and black suit in sunlight do not represent an average subject: the distribution of light and shade might be evenly spread to produce a light-meter reading equivalent to an all-grey subject, but the brightness range from shadow to highlight extends way beyond the range that can be printed satisfactorily – even if the exposure is absolutely correct. If your exposure is out by a couple of stops either way, the detail in the dress or the suit will be lost.

Which meter?

Most users of medium-format cameras rely on a handheld meter – an incident light reading is the best to use. Held in the same light as the subject and pointed towards the camera, this gives very reliable results. However, it is not always practical to take incident light readings – for example when perched in an organ loft – and in such cases remove the incident light receptor, and take a reflected reading. A meter where the receptor can be slid aside is more convenient than one which requires it to be unscrewed.

Built-in meters

Built-in light meters are very sophisticated, but many systems, particularly in SLRs, are calibrated for use with transparency film. This means that they meter principally for highlights, and additional care must be taken with black-and-white film which requires exposing for shadow detail. Point the camera towards the shadow area to take the reading, retain it and then reframe the image.

Colour film

Colour negative film has at least three colour-sensitive layers tuned to provide optimum film speed at a prescribed colour temperature. When exposed on a dull day or in shade, the sensitivity of the layers is no longer balanced. To compensate for the extra 'coldness' of the light, increase the exposure by about one-third of a stop.

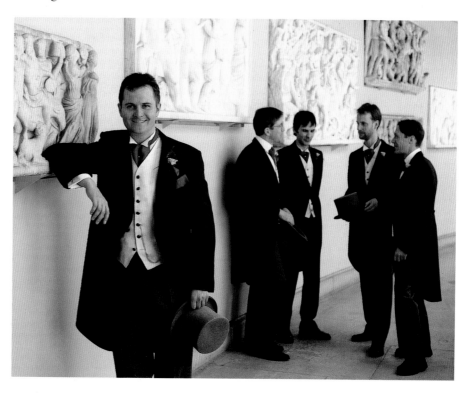

Right: The whole frame
In this shot, a reading from the whole frame would be more or less evenly balanced, but a centre-weighted reading would result in overexposure. Again, an incident light reading would give the correct values.

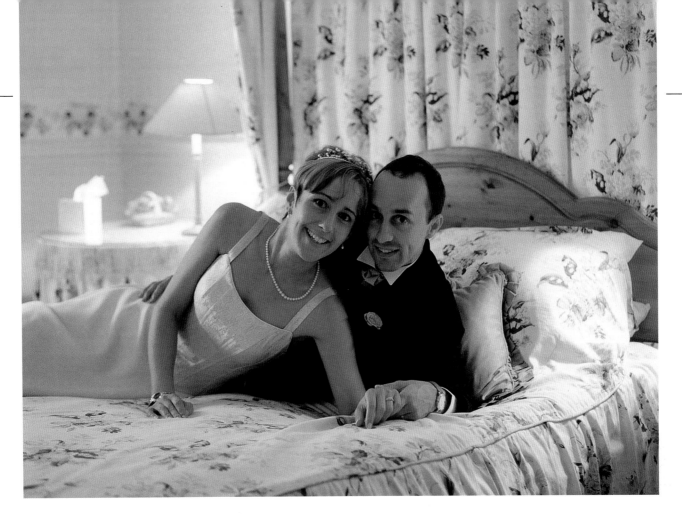

Above: Using available light
An available light reading taken with the meter beside the couple, pointed towards the camera has ensured the character of the bedroom with its bedside lighting has been retained. Note that the photographer has failed to observe and remove the box of tissues in the background. Although 'realistic' in a photo reportage photograph, this is a sign of sloppy technique in a posed portrait like this.

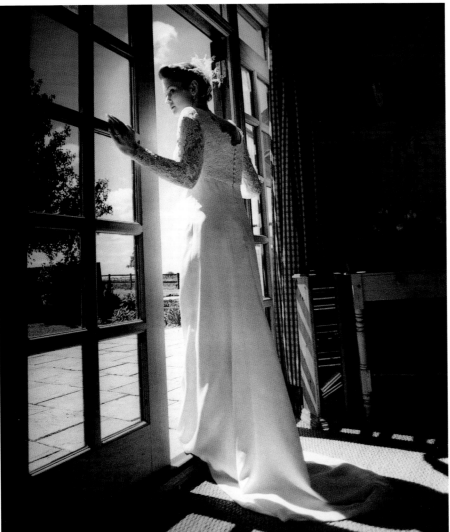

Left: Coping with contrast
A tricky shot for calculating exposure. There is an enormous contrast range here, which has been compensated for in the printing. This could be have been read with an incident light meter held by the bride's face or with a built-in meter reading taken mainly off the rear of the dress.

Getting it right on the day

Arrange a meeting with the couple at least two weeks before the wedding. Use this time to take notes, formulate detailed plans and get to know them in a relaxed setting. This gives you two weeks after the meeting to check out the location, introduce yourself to the people at the venue and go back to the couple if there are any special observations or difficulties.

Tell the couple what you plan to photograph and show them examples. Ask them if they have any special requests – special guests who may have come halfway around the world perhaps, or a particular group of school friends. But apart from any such 'specials', ask the couple to leave the photography up to you. Avoid creating a list of 'must-have' photographs – it may not be possible to stick to it, and this could cause bad feelings later. Make a note of the names of parents and also of all the bridesmaids, ushers and the best man, (or woman) or supporters so you can address them by name.

The ceremony

You need to know full details of the ceremony that will take place. Details can vary considerably even within the same religion or denomination, and civil ceremonies are held in all kinds of buildings and settings. Make notes about when special readings and music will occur so you can position yourself in the right place at the right time.

The reception

It is important to decide with the couple where the formal and casual photographs will be taken and when. Will you spend a few minutes with the couple as soon as they arrive at the reception venue, or after they have greeted everyone? Many people do not realize how long a formal receiving line can take. If the couple opt to have a less-formal handshake on the way into the meal, it takes a lot less time, partly because everyone will have arrived, and partly because they will be hungry!

No flash

At some religious ceremonies you can move about as much as you like and use flash photography, but try to resist the temptation. Be discreet if moving around and use available light unless you are attempting to capture movement. By avoiding flash photography, you will give a more accurate feeling of the occasion. At some churches you may only be able to take photographs from the back, in others you may be offered the chance to go into a gallery or the choir stalls.

Transport, route and parking

Enquire how the couple will be travelling. If it is a pony and trap it will take a lot longer than a car. Are they taking a picturesque route? If so, you should precede them and take pictures. If the church has reserved parking ask them to allocate a space to you.

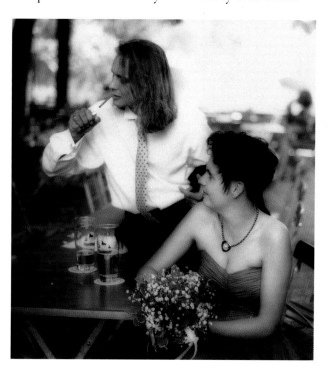

Left: Informal or formal?
Some couples want strictly formal coverage, others informal. Many will want a mixture. Find out from your meeting what the wishes of the couple are. Time is limited at a wedding, and you can only do so much.

Left and below: The ceremony

During religious ceremonies some clergy will allow you a good viewpoint, others are less helpful. It often depends how photographers in the past have behaved. If you don't know the ground rules of the venue, check if anything has been said to the couple beforehand. If there is a balcony from which you can get a good view, you won't have to get so close. Take several shots of the ceremony with different lenses. Always remember you can enlarge part of the image if necessary. The pronounced grain is often regarded as a feature.

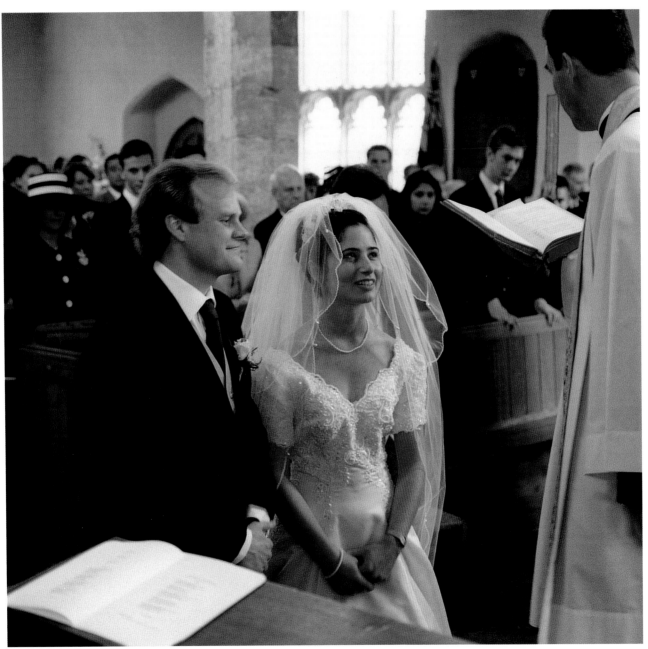

Preparation and reconnaissance

Armed with information from the briefing meeting, you need to carry out a reconnaissance at the venues if you have not been there before or for a long time. If possible, do so at the same time of day as the ceremony or reception so you can check the light. Walk around and plan where you will take photographs. Make up your own mind – do not be influenced by someone telling you where they are usually taken.

In addition to your first-choice locations, devise reserve areas in case you suddenly find a parked car in the background of your shot. Examine the interior of the reception venue in case you are forced indoors by rain.

No garden?

If the hotel gardens are limited or non-existent, check to see if if there is a park nearby where you can take the couple for a few portraits. There are often excellent but little-known places you can visit. Ask the couple to check with the car hire firm – they often know of great sites.

Ideas for shooting locations

Gather ideas from different mediums – study magazines and television and keep favourite images with you on the day for when inspiration fails. Do not be seduced by the location, you will only have time to use two or three spots close to the building. Choose only those easy to get to and which give you alternative backgrounds and lighting.

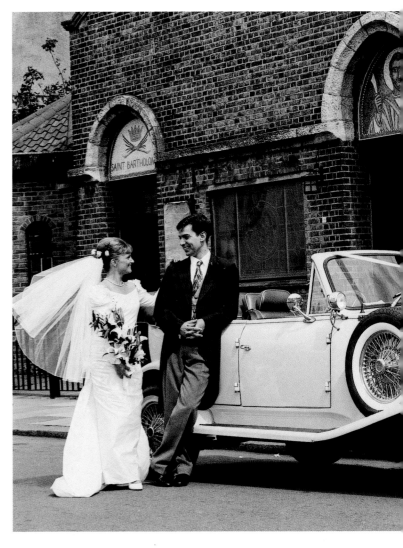

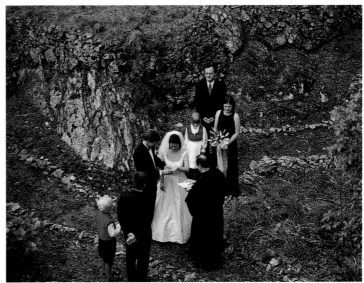

Right: Unusual ceremonies
If the circumstances are really unusual, such as this Irish outdoor wedding, make sure you are fully briefed on the events of the day.

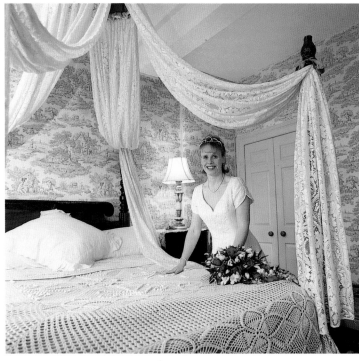

Left: The venue
Even if the wedding venue is not the prettiest of buildings, you must still feature it in your photography. If the car is elegant, put it and the couple together for a more interesting picture.

Above: The bridal suite
Civil weddings often take place in an hotel, and the couple may have the bridal suite. Take advantage of this location to get portraits of the bride beforehand.

'do not be influenced by someone telling you where the photos are usually taken'

Timetabling the day

Your schedule must be planned beforehand, and the couple have to understand that if there are delays for any reason, they will either miss out on the portrait photographs or the meal will be served late. Good planning and an understanding of exactly what the bride and groom want will help prevent any problems.

At home

If planning to photograph the bride at home, calculate how long it will take you to travel to the ceremony, and tell them you will arrive an hour before they leave. If you are lucky, you will get up to thirty minutes with the bride and her family.

At church

Plan to arrive at church a few minutes before the bridegroom, who should arrive thirty minutes before the ceremony for portraits and casual pictures with his attendants. Bridesmaids should arrive twenty minutes before the bride.

Afterwards

Establish how long the ceremony is. Plan to spend up to twenty minutes on groups at the church and later another twenty on portraits of the couple. The casual pictures are taken before the meal while they have drinks and socialize.

Working as a team

As the photographer, you are part of a group of wedding professionals helping to ensure that the bride and groom have a wonderful day. Be friendly and helpful to the chauffeur, the officiant, the banqueting manager, the toastmaster and anyone else involved, and they will help you too.

Deliver – do not post – copies of photographs that depict their contribution to the occasion. They will use these to show future clients, so make sure they are in a folder with your name and telephone number on it. You could gain a lot of future business in this way.

If you work well with the video operator you can be useful to each other. For example, you can give the operator time to get into position in the choir stalls while you detain the bride at the door. Give the video operator a 35mm compact camera with fast film in and ask the person to take a few frames for you. They will all add to your coverage. In return, supply a still picture taken from the rear that he or she can cut away to when editing the video.

The ceremony

If the ceremony is to take place at a church or synagogue where you do not know the customs, make sure you visit the officiant beforehand. You could ask to sit in on another wedding there as an observer. No one will know or bother about who you are, but you will be able to see the form and work out when photography might be possible.

If the venue is a synagogue, remember men will have to wear a yarmulka (skullcap) in the building, but they have them (or trilbys) available for visitors.

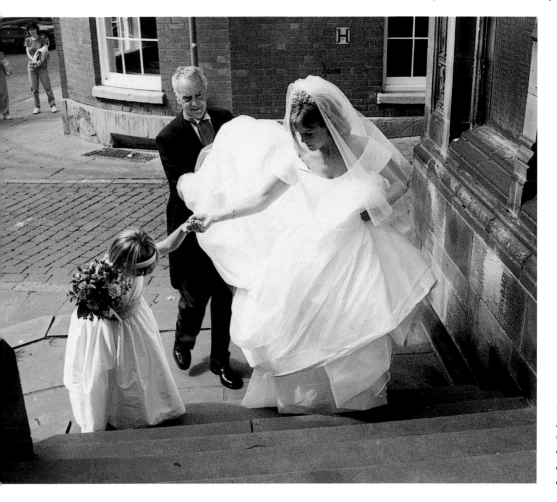

Left: Saving time
If the bride is late, do not hold proceedings up further. Simply take reportage pictures of her arrival.

Facing page: Know the service
At this Greek Orthodox service the priest leads the couple around while the guests throw rice. It can be quite painful, so the bride ducks behind!

Learn the form of the service. In some cases the registers are signed in a rear room, in others as part of the ceremony; sometimes during the ceremony, in others at the end. Establish how long the service will be; occasionally a religious ceremony can go on for a very long time, while a civil ceremony in a register office can be over within five minutes, signing included.

'you are part of a group of wedding professionals helping to ensure the bride and groom have a wonderful day'

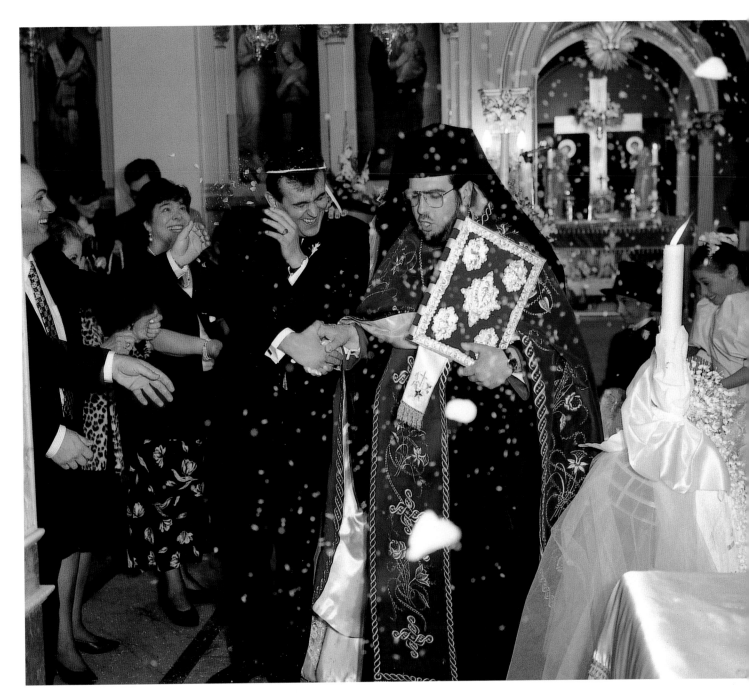

Part 2

TECHNIQUES

You have been booked to photograph the wedding so the parties involved can have a record of what they hope will be the happiest day of their lives. It is part of your job to show them at their most attractive. Photographers need to be magicians. Plump people want to be made slimmer, tall ones shorter. You cannot change their shape, of course, but you can create positive illusions. These can be achieved with lighting, careful posing and arranging.

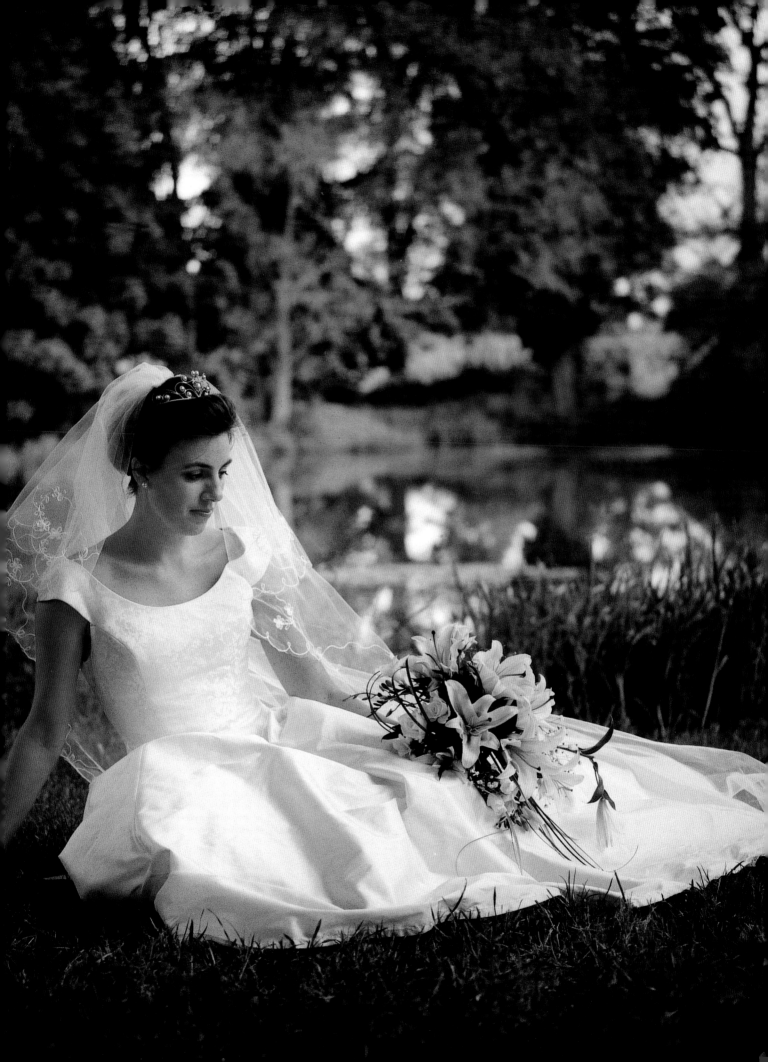

Simple posing

As statues through the ages reveal, it was discovered a long time ago that human beings are more attractive to the eye when the head and shoulders, arms and hands, and legs and feet are positioned asymmetrically. While dancers and actors have learnt posing for themselves, the majority of the public are unaware of how to stand or sit to look attractive and relaxed. Fortunately, it is very easy for the photographer to instruct the subjects, and this is best done by demonstrating to them.

Start with the feet

The basic rule is that no one should be standing to attention, both feet together. Instead, the shoulders should be at a slight angle to the camera and the front foot should be brought forward a few extra inches. Weight should be dropped onto the rear hip as this has the instant effect of causing the forward knee to bend and the rear shoulder to become lower than the forward one. The head should be tilted so that a line through it would be at right angles to a line across the shoulders. The arms should be bent slightly to create a pleasing curve.

This pose can be used for men and women and should be adopted even for close-up pictures where you do not see the feet, and also for full-length bridal portraits as the bent knee will give shape to the dress. For women the head can be turned and tilted to the higher shoulder, creating an attractive S curve from head to toe, but this pose is inappropriate for a man.

When posing two people together it is usual to have them standing at a slight angle to each other. If the bride is on the groom's left she brings her left foot forward, he his right, and they both let their weight rest on the rear foot. This causes them to lean slightly towards each other, making an attractive couple.

There are many things to take into consideration: you have to pose the couple attractively, showing the dress to advantage; you have to position them against the background in a way that adds to the storytelling, and you must ensure the overall composition is good.

Above: Too posed
Stood directly in the doorway the couple would be facing the sun so the photographer turned them to the side. However the pose is too stiff, they are standing as individuals not a couple, and the dress has not been displayed to advantage. The camera is looking down on them.

Above: Relax the arms
Here, the dress has been arranged, but the individual body posing is still too stiff. The arm holding the bouquet is too straight; arms should always be curved to create a more pleasing and natural line.

Adding and subtracting visual weight

You can add or subtract pounds to a bride, or anyone, through your choice of camera angle. The points to consider are:

■ The nearer to the camera a subject is, the bigger they look.

■ Not enough space around a person makes them appear bigger.

■ Camera height. See pages 28 to 29.

■ Arm position – you need to show daylight between the sleeves and the bodice to make the figure less solid and bulky.

■ The scale of the person relative to their surroundings.

Facing page: Classic composition
The couple have now been repositioned along classic lines: they both have their weight on the back foot with their bodies leaning towards each other, making it a pose of a couple rather than two individuals. The bride is in front of the groom, and they are posed so that they look as if they are coming from the church. The bride's arms are curved and the camera has been lowered to waist height, giving them greater stature. Note how they are positioned in the frame with twice as much space above them than below.

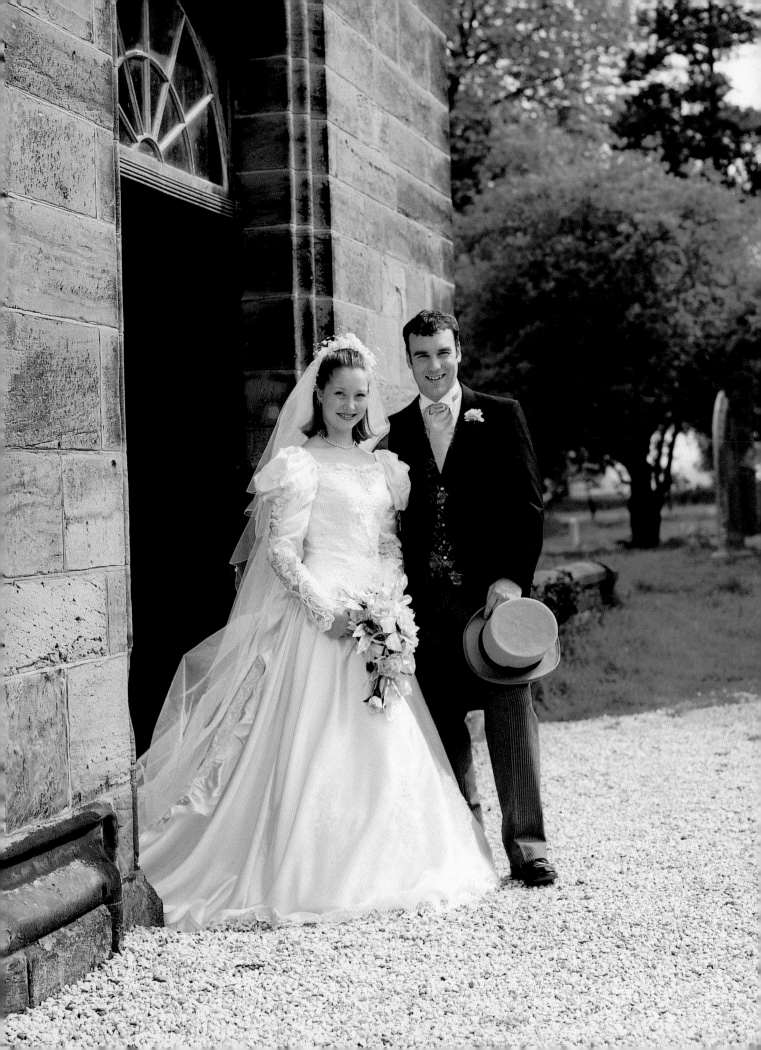

Posing the bride

Portraits of the bride are among the most important you will take. Getting a formal portrait is therefore crucial. To display her dress properly she must stand well. Although you may only be taking a three-quarter-length or head-and-shoulders portrait, you still need to start the pose at the feet. With her feet arranged with one in front the shoulders will be at their most flattering, one higher than the other, at an angle to the lens. The most feminine position for her head is to have it turned and tilted to the higher shoulder. This places the entire body into an S-curve, a classic pose that has been appreciated for centuries.

The bouquet should be held in the same hand as the foot that is placed forward – if the left foot is placed forward, the left hand should hold the bouquet slightly to that side. The right arm should then come in to meet the other at wrist level. Brides have a tendency to hold their flowers at waist level. This is not ideal for two reasons: it results in the elbows being at almost right angles – when a much wider angle is preferable – and it hides the waistline, which tends to be an important part of the dress design.

'The most feminine position for her head is to have it turned and tilted to the higher shoulder'

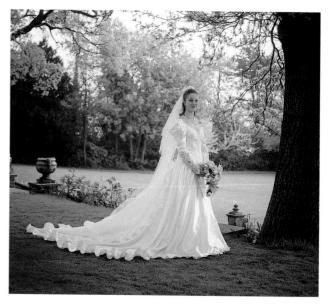

Above: Dress display
Take plenty of photographs of the bride to show the dress from all angles. Here she is side-on; the train has been displayed behind her. Note how she has been placed beside the tree so that light creeps round. This provides a rim light to her (two-thirds) face and dress. The detailed train also catches the light. A Pro-4 low-key vignetter has been used to darken the corners of the image to create a good effect.

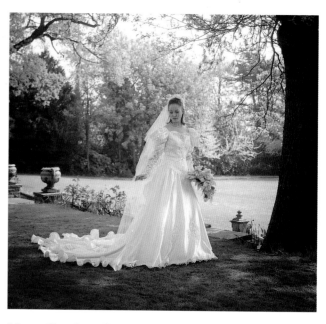

Above: Showing off detail
In an alternative pose, the bride holds the veil so we can see the delicacy of the material. Instead of finger and thumb, it is held between the second and third fingers. The direction of the face and the expression are appropriate to the context.

Head angles

In many photographs, the head of the subject will be facing the camera square-on – both ears can be seen. A face is at its most attractive when it is at a slight angle (seven-eighths face) or further turned to two-thirds face (so-called because you see the whole of two of the three planes of the face). In these positions you see better the shape of the face as defined by the cheekbone. The third classic position for a face is full profile. However, this should be used with discretion.

Classic head positions

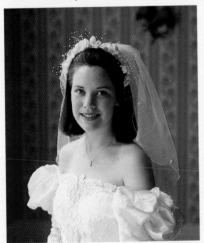 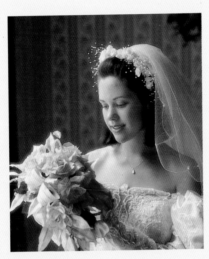 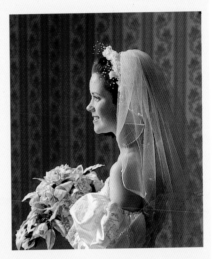

Seven-eighths face

Two-thirds face

Full profile

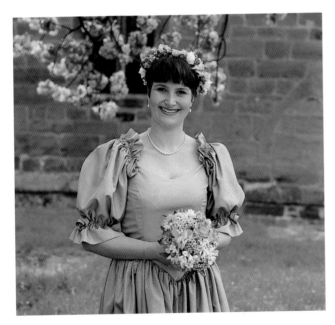

Above: All the basics
This bridesmaid has her right foot forward, her head is at right angles to her shoulders and she has been photographed from eye level. This is a pleasing portrait, with soft lighting from the side and a reflector at the base to compensate for a lot of top lighting. Nevertheless, improvements could be made, for instance the sleeves merge with the dress so we cannot see the waist.

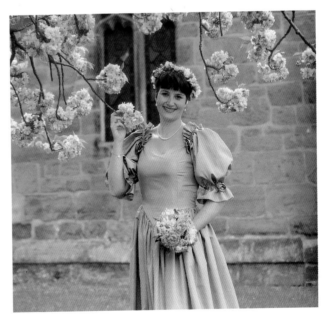

Above: Enhancing the effect
Here the same bridesmaid has been photographed from a little further away and with a lower camera height. This makes her look taller and slimmer. The arm angle enables the waist to be seen, and the bouquet has been lowered. Her head tilts toward the front shoulder – a more feminine pose. The blossom and the church window give depth to the picture and add to the story.

Posing the bridegroom

The bride receives most of the attention on the day, but it is important to get flattering portraits of the bridegroom too. The best time for this is before the ceremony at the church or wedding venue, when according to tradition the groom will have arrived in advance with the best man and groomsmen.

Start with the bridegroom, taking alternative pictures making use of the settings provided and ensuring that you have good lighting. A full-length portrait of a man can be difficult to achieve – particularly if he is tall and thin – unless you have a suitable, well-lit setting. Often it is better to take a three-quarter-length portrait.

In line with the rules for posing described earlier, the groom should be posed at a slight angle with one foot slightly forward and the weight on the back foot. When photographing men, always check that the ties are properly knotted and if they are wearing waistcoats (vests) that they are correctly buttoned, with the bottom button undone.

Fitting everyone in

After photographing the bridegroom alone, he must be recorded with his best man and then with all his attendants. When building groups, you will have plenty of scope for interesting pictures. With the men all dressed formally, do you put them all in the same pose? Or do you try and show their own individuality beneath the suits? It's up to you. Whatever you do make sure the bridegroom occupies centre stage.

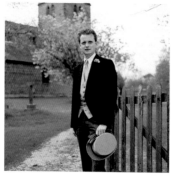

Above: Room for improvement
This basic pose is acceptable, with the waist-level camera viewpoint giving the subject height and the church in the background, but not enough thought has been given to the composition or the lighting.

Right: Repositioning
Here, the camera has been repositioned to include the top of the church tower. The pose has been slightly modified – his right hand is now in his trouser pocket, giving a better line to the sleeve. The hat is held higher; the bottom of the photo is cropped through the legs above the knee. A Pro-4 low-key vignetter darkens the corners and pulls the picture together, giving it greater integrity.

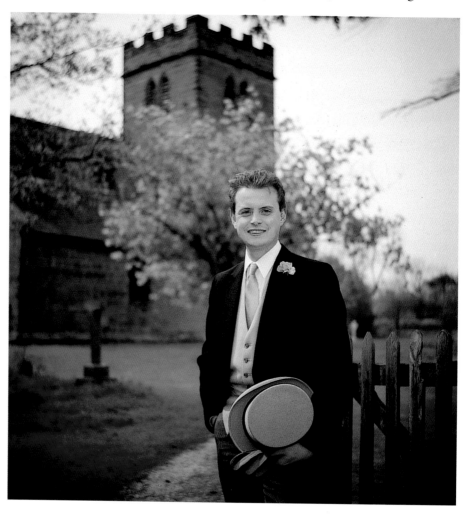

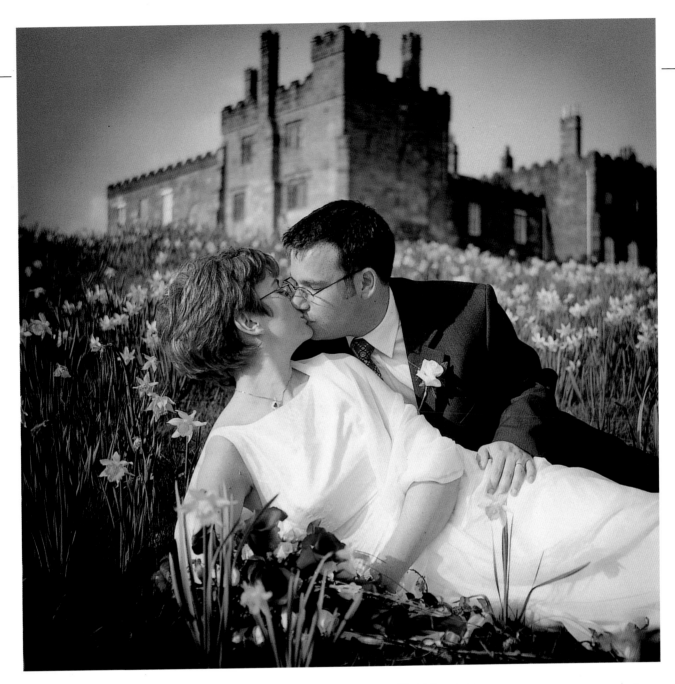

Seated suits

Whenever a man is seated it is necessary to check his clothing. He should generally have the jacket unbuttoned to prevent it looking tight. If wearing a morning suit he should also avoid sitting on the tails as this too mis-shapes the coat. Similarly he should avoid putting an arm around his bride's waist but should place his hand in the middle of her back. If he has appropriate cuffs they can be pulled down to be visible.

A handy solution

Hands can be a problem in photographs because, despite their small size, they attract attention to themselves, particularly against dark or light clothing. They can especially cause problems in seated groups, where at first glance you might think there are more hands than there should be. The answer is to hide as many hands as you can behind flowers, hats or other people.

Above: A romantic portrait

The bride should pose on the ground first in the right position relative to the background. Then it is easy for the bridegroom to move behind her. Note again the minimizing of hands – just the groom's left hand, with his ring, is visible. A Pro-4 low-key vignetter has successfully darkened all but the central area.

Posing couples within a setting

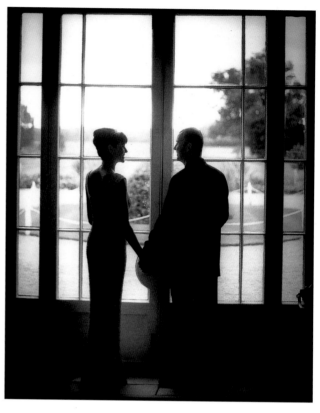

Use individual settings and venues in order to create a unique story-book for the couple. Rather than working to a formula where you create the same images every week, make sure you feature the couple in their chosen venue. This is an essential requirement of wedding coverage, but the need to work quickly cannot be overemphasized. How is this compatible with taking a good variety and quantity of pictures?

The answer lies in setting up each pose so that with very little effort you can take a second, quite different, picture. There are a number of ways to achieve this. A simple way is to move to the other side of the couple to include a different background. Then you could move in close to the couple for a close-up. You can raise or lower the camera to create a different perspective, and last, you can ask the couple to look in a different direction to capture a different facial angle. Then it's a case of combining two or more of these ideas to vary the pose and create a stunning new shot.

Above: Balancing the shot
The location suggested a silhouette so very little was required of the couple other than they be seen in profile. It was a clever touch to position them this way – while the bride is seen clearly within the frame, the somewhat larger bridegroom is partly obscured by the door frame. The picture is much better balanced as a result.

Left: Kissing hints
Kissing shots often result in both faces being lost. Here, a little direction ensures we do not lose the bride's features. Her hand on his head adds tenderness, and their arms and the dress have been positioned in a triangular shape.

Facing page: Dress and setting
If you are photographing on a beach the couple need to dress accordingly, so bare feet were required all round in this shot. The relatively small scale of the couple serves to emphasize the location.

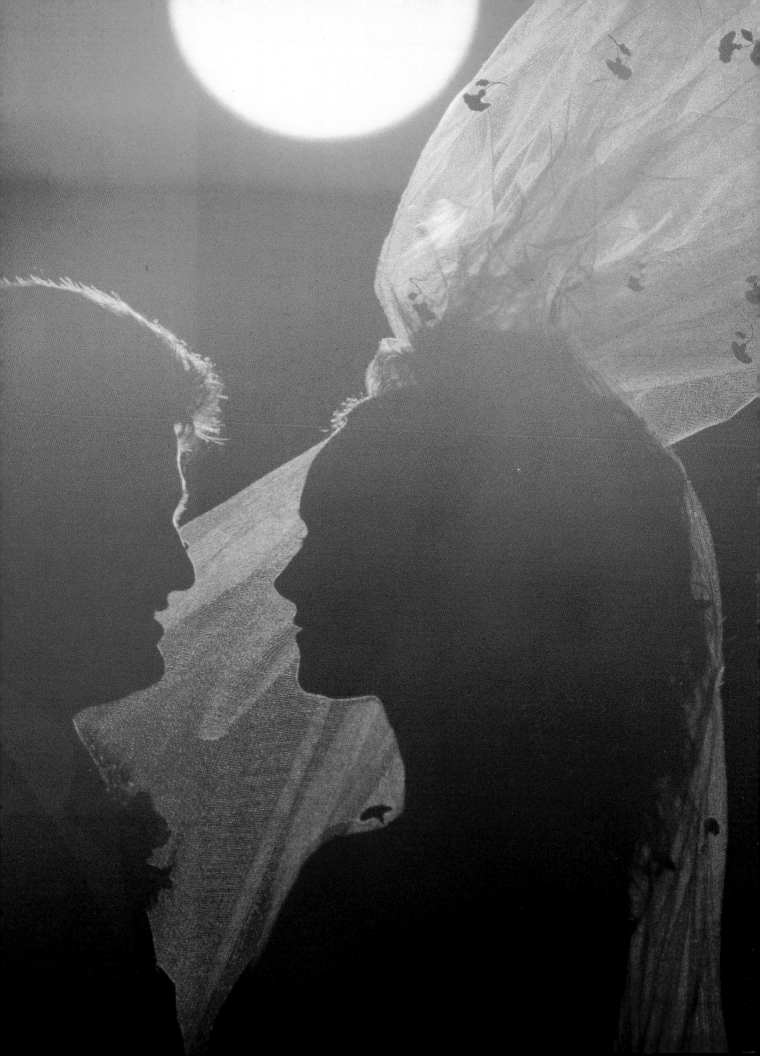

Lighting decisions

A frequent lighting dilemma is rapidly changing weather conditions, when the sun keeps disappearing behind fast-moving clouds. On an unpredictable day, it is no good setting up a series of group shots while the sun is behind cloud, to find part of the way through taking them that the sun is shining directly onto people's faces. At times such as this, you need to be aware of where the sun is and where it is going.

Before taking each set photograph, whether it is of the bridegroom arriving at the church, formal or informal groups, or the cutting of the wedding cake, you should always ask yourself two questions:

• What is the best background for the shot?

• Which is the best position for the photographs from the point of view of lighting? In some cases, the two coincide and you will get the background you want — one that contributes to the story of the wedding —

as well as a good light source. However, it is not always so easy.

The background may be inappropriate — a busy road, for example. Or the wedding party may have requested a photo in front of the church, and this could mean posing them in direct sunlight. The optimum illumination on a sunny day is often backlighting (so that people are not screwing up their eyes against the sun), which gives attractive rim lighting.

The best solution is a compromise. The aim in wedding photography is to tell the whole story, not in one picture but in a series of photographs. So long as the setting is shown in at least some of the photographs, the shots that can be described as portraits should be taken in a position that provides good lighting against an unobtrusive background. Finally, if you have to choose between background or lighting, lighting must win the day.

Left: Grand setting
If the setting for the wedding is a castle, it must of course be featured. Here, the light is not good for a formal group, which would look better in the shade of the bushes. The photographer has chosen to make this photograph a semi-formal group. The rather harshly lit faces are acceptable here because they are just a small part of the whole picture.

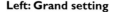

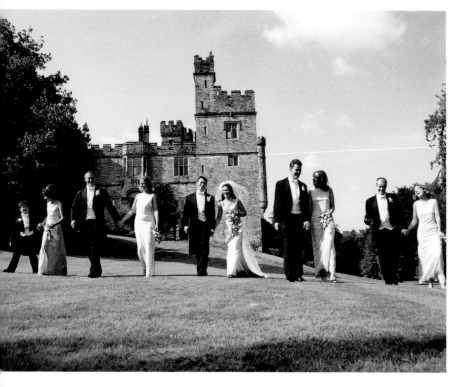

Right: In the shadows
When using backlighting always be aware of shadows which could contribute to the composition.

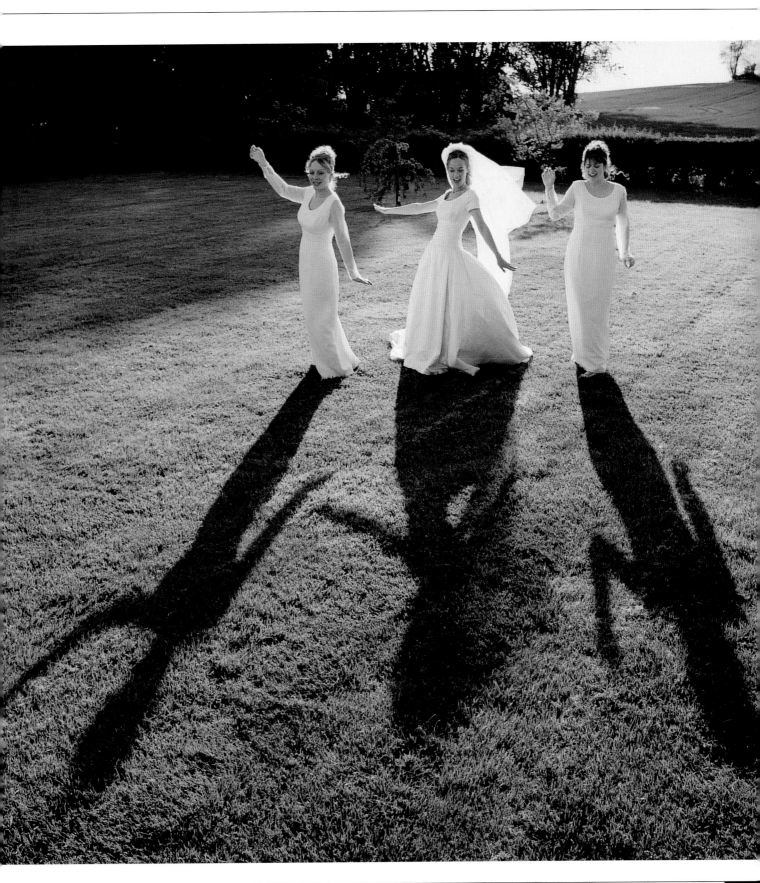

Light direction

The photographer must be able to 'read' the direction of the light quickly and adjust the shot accordingly. When the sun is shining this is easy, but it is more difficult when there is overall cloud or when working in a shaded area.

You have very little time to fine-tune lighting on individuals. The ideal situation, therefore, is a large, soft light source – for example, cloudy sky on one side with some large overhanging trees on the other. These features provide modelling on faces and ensure there are no dark eye sockets caused by dominant light from above creating shadows.

Even on an overcast day, except in the middle of a field, the light will be coming from a particular direction as a result of screening from buildings and trees. The light direction needs to be ascertained before photography begins. Do not be fooled by quantity of light. The area under trees may look dark, but this is not a problem if you are using a tripod and can increase exposure.

If top light is dominant and the faces looking towards the camera have dark eye sockets, change the composition of the picture: ask the participants to look towards each other, or out of the frame, so that the top lighting illuminates their profiles.

Finding the light

A simple trick is to use a small piece of folded white card which will fit in a top pocket – say 75 x 100mm (3 x 4in) folded lengthways.

1 Held with the fold vertical towards the camera, the card indicates light is coming from the left, and if the lighting ratio is acceptable without the need for flash fill or reflectors, one side will look white, the other light grey.

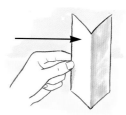

2 Held with the fold horizontal to the camera, the card indicates that light is coming from the top, and this could result in shadowy eyes, for which a fill light or repositioning may be necessary.

Facing page: Ideal setting
This is a perfect place for portrait pictures of an individual, couple or group. Beneath large trees there is no top light, but a large, soft source from the left which provides wraparound lighting from the side and front. Trees on the right reduce the amount of light coming from this side, giving good modelling and roundness to the faces. In addition to this, a delicate soft filter (Pro-4 Full Soft) adds a touch more smoothness to the skin, and a low-key Pro-4 vignetter darkens the corners. In a location such as this, it is easy to take several different portraits in a couple of minutes.

Left: Top lighting
The lighting here is mainly from the top, as you can see from their hair. If the people were looking at the camera, they would have dark eye sockets. Having planned a picture in which the group is walking towards the camera, the photographer has turned them to face each other so that the top light highlights their faces. Observing the light and reacting accordingly is a skill the wedding photographer must cultivate.

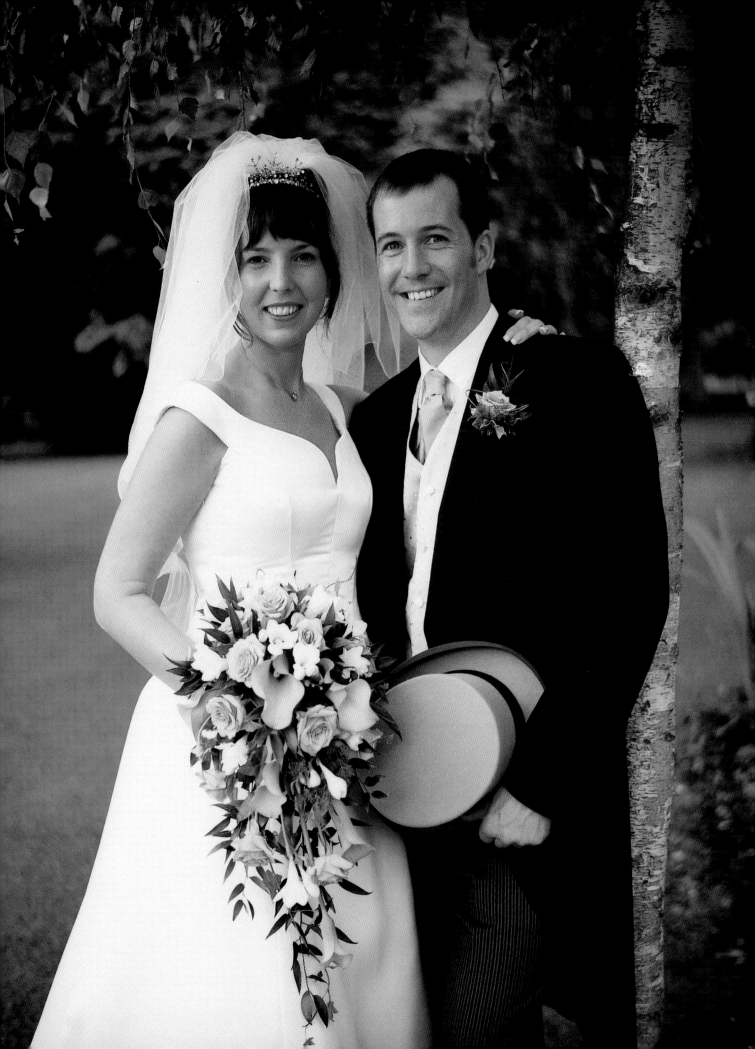

Window light

Light coming through a window is one of the wedding photographer's greatest tools for a number of reasons. Most rooms have a window, however small, the quality of light is flattering, the light can be controlled and finally, window light enables you to work very quickly as you do not have to set up flash units.

Light from a window provides just what you need when photographing an individual or couple – a large, soft light that is bigger than most studio soft boxes. If the sun happens to be shining through the window, it can easily be diffused by leaning a 1.2 x 1.8m (4 x 6ft) illumination diffuser against it. This provides side-without top lighting, so there is no problem with dark eye sockets. Also, the light can be controlled by drawing the curtains. Opened, they give a broad source that lights up the background as well. Drawn, the light source is narrower., which can also help mask a cluttered background.

Wet and windy days are occasions for taking pictures indoors, but such is the quality of the light provided by a window that many photographers take advantage of it at every wedding. For example, place your subject next to a window and you can achieve several different effects with the side light it creates. Move the subject away from the camera, so the window light falls in front of them, and the foreground will be lit, move the subject close to the camera, so the window light falls behind them, and the background will be lit. Alternatively, partially close the curtains so only a narrow shaft of light illuminates your subject.

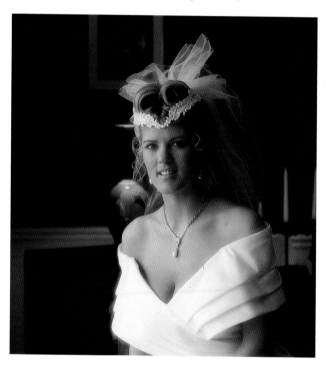

Above: Narrow light
In this photograph the curtains have been drawn to give a shaft of light that produces narrow lighting, illuminating only one plane of the face. The background is thrown into shadow.

Positioning the bride

a b c

In (a) the bride is at the far end of the window, the light illuminating both her and the foreground. In (b) she is positioned close to the camera and receives less frontal, more side and back light, with the background lit. The curtains are partially closed in (c), to highlight the bride with a narrow shaft of light and to throw the background into darkness.

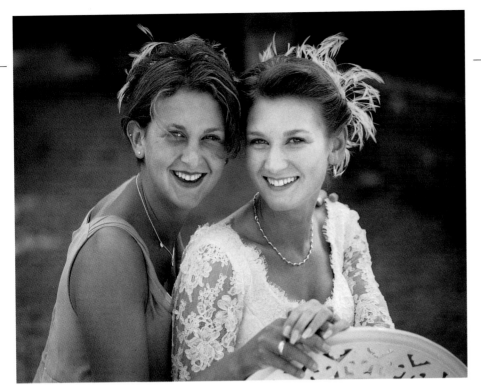

Left: Lighting the eyes
Even in very soft lighting conditions you need to get light into the eyes. A white reflector placed below the subject, out of the camera's view, is a simple but effective way to do this.

Using a white reflector

Place the reflector below the camera so it bounces light into the face of the subject. Move the reflector about whilst observing the eyes until you have found the best position.

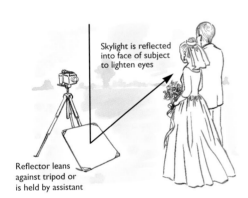

Skylight is reflected into face of subject to lighten eyes

Reflector leans against tripod or is held by assistant

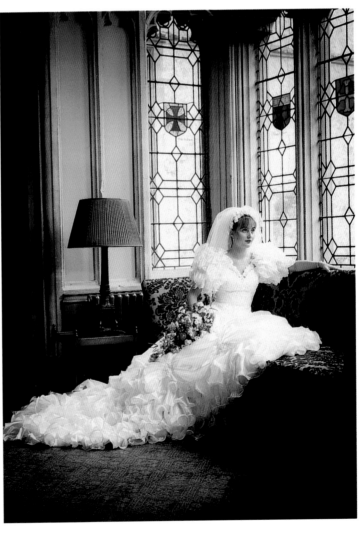

Right: Vignetted bride
Take care when getting the window in the picture as this can result in a large, solid white area. Here, the white area is minimized because of the leaded lights and the stained glass, as well as the use of a vignetter to darken the corners of the image. The photographer has also used a reflector beside the camera in order to provide some fill light.

Flash fill

Press photographers seem to use flash on every picture, and nowadays very sophisticated flash units are available which, working in conjunction with the camera, cut off the flash when the subject has been judged to have had enough fill illumination.

In theory this is fine and it means that the photographer can concentrate 100 per cent on the subject before him, the composition and the expressions. Unfortunately it overlooks the whole basis of photography, which is the creation of images based on shapes, depth of image and texture, all of which owe their portrayal to lighting. Full-frontal lighting as produced by a flash on the camera results in two-dimensional pictures which fail to bring out the character of the individuals and the mood of the occasion.

Also the flash unit itself can often produce a hard shadow, and if it falls wrongly this can be unsightly. The shadow can be partially reduced, however, by the use of an appropriate bracket which holds the flash unit directly above the lens.

With a flash gun permanently attached to the camera and in automatic mode it is too easy to forget about looking for the available light and using it to recreate the mood and atmosphere of the occasion.

This is not to say never use flash, but it should be used intelligently and only when it is really required. Unlike press photographers, whose work is reproduced within a very limited density range, a wedding

'When using flash as the fill light, the advice must be less, not more'

photographer's output is original photographic prints capable of reproducing a good range of tones from white to black.

When using flash as the fill light, the advice must be less, not more. Set the flash to provide at least two stops less light than it would normally do, and after experimentation you will probably find three stops less gives a more natural result.

You can do this by kidding the flash that either you are using a faster film or a larger aperture. For example, if the meter reading gives you f/8, set the flash as if you are using f/4 (-2 stops) or f/2.8 (-3 stops). But before switching on the flash at all, use your eyes, see the ambient light, and ask yourself if you need that flash. To begin with and until you become confident, take two photographs, one with flash and one without, or at two different flash settings and examine them critically. In this way you will soon learn for yourself how to use fill flash properly.

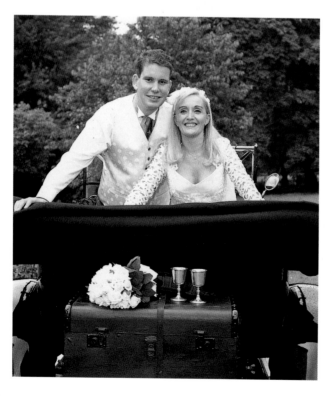

Left: Some fill needed
An outdoor picture would not normally need flash, but the excessive top light created by the trees all around indicated that some fill was needed, especially to record the dark area at the back of the car. A reflector was not practical, so -2.5 stops flash was used as a fill.

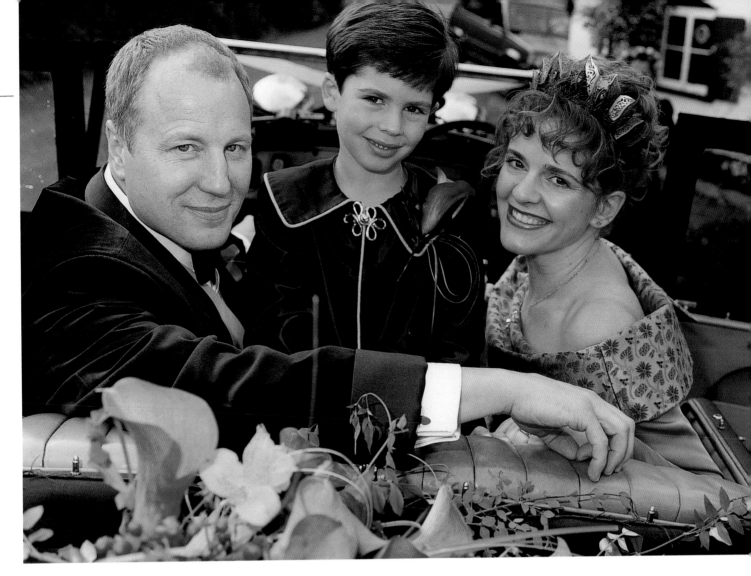

Above: Low-key flash
Here, the overcast day, together with trees to the left and behind the photographer, would have resulted in the faces being in darkness without some fill light. With a hand-held camera and no assistant to hold a reflector, the photographer used flash purely as a fill, to balance the ambient light beyond.

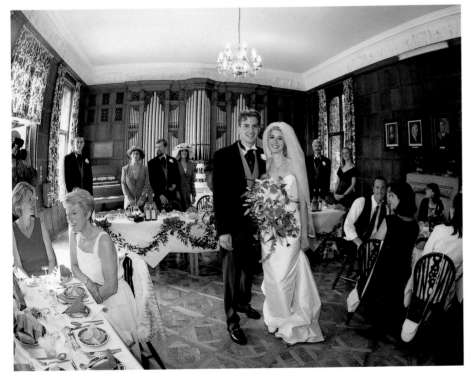

Left: Wedding breakfast
A fish-eye lens covers a much greater angle than a normal lens, so you would think a normal angle flash was inappropriate here. Most of the room is illuminated by daylight and exposed accordingly, but the photographer has added flash at -3 stops, directed at the couple. This adds a sheen to the dress and makes sure that the faces of the couple are well lit.

Using flash as main light

There are times at a wedding when flash becomes essential as the main light. These are usually indoor shots and may be either posed portraits or group pictures, or sequences involving some action. A flash attached to the camera may be the most convenient place for carrying and ease of use, but it provides the least pleasing lighting. This is partly because of the nature of the light produced – flat frontal lighting – but also because the intensity of the light rapidly falls away if the subject has any depth. People near the flash may be lit too much and those furthest from it too little, a totally unsatisfactory situation.

Fortunately, there is a simple solution to this problem which works for the majority of wedding photographs. This is to use a slow shutter speed so that there is a high level of ambient lighting in the photograph, particularly in the background.

Bounced flash

The two main problems with flash – a small reflector and fall-off – can sometimes be overcome by bouncing the flash off the ceiling. Many flash guns can be tilted up, towards the ceiling. While this can be useful, it brings its own set of problems, mainly by producing excessive top light which causes shadowy eyes. Manufacturers have now introduced units with two flash components – a main head to bounce light off the ceiling and a secondary one to fill in.

An equally satisfactory device can be made at home, using any efficient flash unit such as the ubiquitous Vivitar 283. All you need is a piece of card, attached to the flash with Velcro. When the head is angled at about 45 degrees, the main burst of light goes up to the ceiling and is reflected to light the background. Meanwhile, light is reflected from the card towards the people, providing a softer, less intense light than would a small flash head on its own.

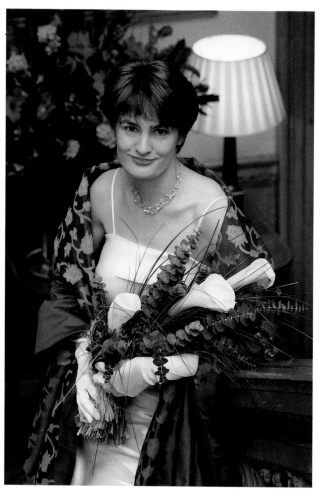

Above: Blushing bride
The flash here is a combination of bounce and direct. You can see the catchlight in the eyes, but the shadow underneath the bride's nose is soft. The lamp in the background has been picked out by using a shutter speed of 1/30th second.

Making a bounce flash

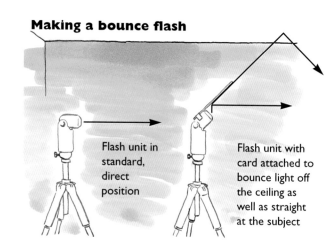

Flash unit in standard, direct position

Flash unit with card attached to bounce light off the ceiling as well as straight at the subject

Right: And so to bed

The field of view covered by a fish-eye lens is large, so here the flash has been moved away from the camera, as revealed by the shadow at the bottom. Although the couple are lit principally by the flash, the bedside lamps contribute rim lighting to their faces. To ensure a good balance between the flash and the ambient light, a reflected reading was taken of the bed, the dark interior combining with the bedside lamps for an average reading.

Combating tungsten lighting

Very often photographs are taken indoors in artificial light and the background, lit by tungsten lamps, is much redder than the main subject, which is lit by a flash. However, as the photographs here show, this need not be a cause for concern, since the effect is usually quite pleasing. Using a slow shutter speed means that part of the illumination on the subject is from tungsten lighting, reducing the overall difference.

This technique is easiest to use when the camera is on a tripod and shutter speeds of ¹/₁₅th or even ¹/₈th second can be used. Do not be worried about the prospect of subject movement at these shutter speeds. The flash will dominate the foreground, and any movement in the background is unlikely to be detrimental. However, even hand-holding the camera, ¹/₃₀th second will often record much of the background.

As the main subject is lit mainly by the high-speed flash, you can often hold the camera for ¹/₁₅th second. The secret lies in using fairly large apertures with low-power flash.

Unlike the situation on pages 48 to 49, where the flash is the fill light and usually set at two stops less than the 'correct' exposure level, in this technique the flash is the main light and should be set normally; the ambient light ensures the background is adequately lit.

Right: Under the arch

In a big city-centre hotel with few windows, flashlight becomes the only option for photographing groups. Choosing the staircase as the background provides more depth than the wall immediately behind the group. The step also places the bride and groom on a higher level than their parents, while the arch holds the picture together. The flash was held above the lens so that there is very little visible shadow. The shutter speed was ¹/₁₅th second and the aperture f/5.6, resulting in the back wall, which is out of range of the flash, being underexposed by a stop and a half. Despite this, the picture looks right and the overall effect is realistic.

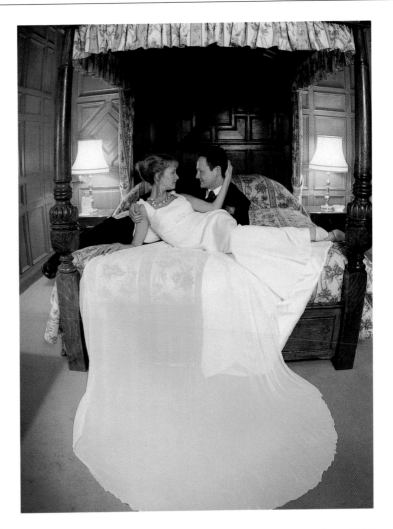

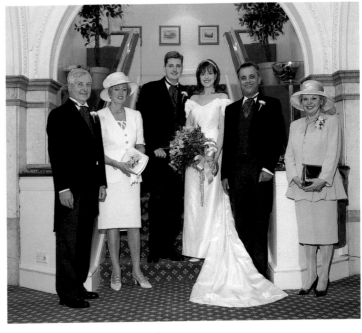

Using flash more creatively

The simple act of lifting a flash gun from the camera invites fresh creativity. Although it takes time and thought and effort, it instantly makes available new picture concepts, which are different from those created by available light and better than those in which the flash is attached to the camera, giving flat lighting.

One of the deterrents to using flash in this way is that you cannot see the result until you print the

Above: Thanking the bridesmaids
Having the flash head away from the camera produces stronger shadows than when it is attached, giving a more three dimensional character to the lighting and also provides more even illumination. Flash fixed to the camera tends to overlight the foreground and underlight the background.

photograph. The small source of light from the head can sometimes cause harsh effects, and there is often concern about the balance of flash with ambient light. However, none of this should be a problem with modern metering practices.

While a small simple flash that can be switched to give minimal exposure is all that is needed for fill flash use, creative work really needs a more versatile unit which will not only be more powerful but enables you to change the characteristic of the light. Made by Bowens, Lumedyne, Norman, Quantum and Sunpack,

these enable you to change the character of the light by either adding a soft box or removing the reflector altogether. This then provides a light source that spreads through 360 degrees. Placed behind a couple, for instance, such a lamp will light up the background behind them and also shine through the veil.

You can put snoots and honeycomb grids (in some cases the same models you use on your mains units) over the heads to project a smaller beam. Some models even have a modelling light built in, but this is of fairly limited use other than for checking for things such as reflections and shadows.

More than one flash

Sometimes you will have a small flash on the camera as well as a main lamp on a stand. In this case, the simplest way of firing the distant flash is to have it plugged into a small receptor cell. It is important that the receptor is able to 'see' the flash on the camera, so a short extension lead is handy and enables it to be suitably placed. A more reliable method, but a more expensive one, is to use a dedicated infra-red system or a radio-controlled signal. The benefit of these is that they are not susceptible to the flashes of other cameras. If flash cameras are going off around you, they could fire your main flash a second or so before you do, and it may not have recharged, so you could lose the photograph.

Flash heads do cast rather sharp shadows, but this can be overcome by putting a small portable soft box on to the head. Several soft boxes are made for this purpose, even one 235mm (9¼in) square will do the trick.

Facing page: Ceiling rose
Here, the composition features the ceiling and the bride has been lit solely by a flash off the camera to the left. The easiest way to calculate the exposure would be to take a spot reading from the underside of the fitting as it was required that this print was a mid tone. If this isn't possible, take a general reading including part of the darker area. Say this indicates ⅓₀th at f/8. Set the camera and flash to this so that whether working automatically or by guide number it will give enough light for f/8.

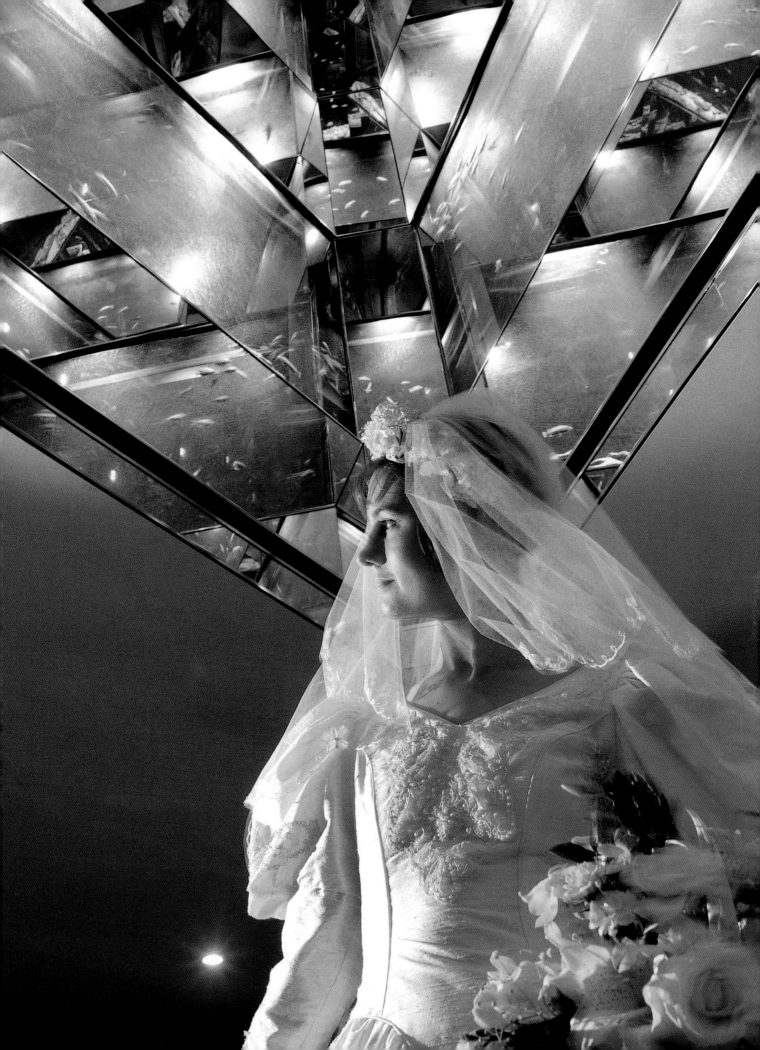

Bare bulb flash

With some flash units you can remove the reflector altogether and use it as a 'bare bulb' flash. With this type of unit, the illumination spills out around 360 degrees, and with some direct light from the relatively small tube, the subject also receives a mass of bounced light from walls and ceiling.

Another good use for the bare bulb head is to hide it behind the couple, lighting up not only the background, indoors or out, but shining through the veil and also providing a rim light for the couple. In this case you will need another flash at the front. Outside, you may be working with the flash head many metres from the camera, so a remote-firing system is required. Both infra-red and radio systems are reliable. It is recommended that you measure the exposure with an incident light flash meter because you are balancing several components.

The bare bulb flash usually has its tube in a clear plastic cylinder about 32mm (1¼in) in diameter. This makes it ideal for the addition of a colour-light filter, which comprises a piece of lighting gel 115 x 63mm (4.5 x 2.5in), taped to form a cylinder. You can also use it clear on one half and have a coloured gel on the other to create, for instance, a pink glow through a veil and normal colour in the background.

Bare bulb flash is commonly used in a manual configuration using guide numbers, as you are adding the flash to the ambient light for a special, predetermined effect. An automatc reading will compute the two together and cut off the flash prematurely, nullifying the effect you are creating.

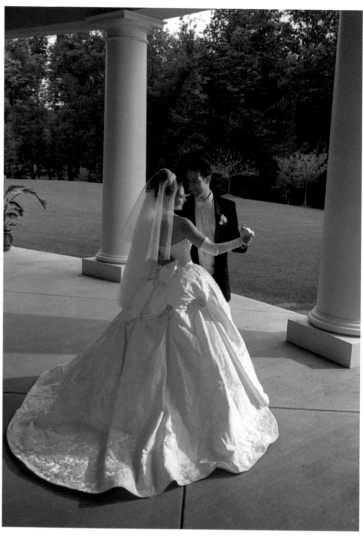

Above: Portable sun light
It looks as if the sun is shining in this photo, but in fact it was an overcast day. The 'sunlight' is produced by flash from the right. Using the bare bulb technique, the lamp is almost entirely a point source since there is nothing to reflect any light back. It therefore casts sharp shadows like sunlight. The exposure is determined in the usual way for ambient light, (here by an incident light meter towards the camera), 1/125th at f/5.6 and the flash positional for the same aperture, f/5.6.

Faking sunlight
The bare bulb flash is placed 7 metres (20 ft) from the couple. Exposure is determined in the usual way for incident light, 1/125th at f/5.6, and the flash is set at f/5.6.

LIGHTING

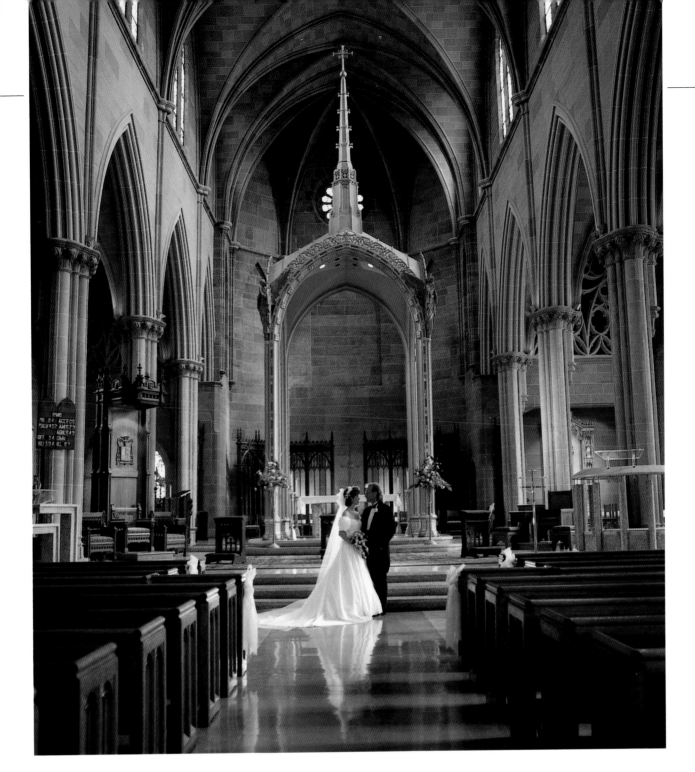

Above: Spotlight on the veil

This is a normal ambient light exposure of a couple in a
church. However, the couple have been separated from
the background with the use of a flash held by an
assistant hidden behind them. This lights up the veil.
The flash could be fired in two ways – by radio signal,
or manually by the assistant. As the ambient light level
is low, the photographer can stop down to get an
exposure of 1 second at f/16 on ISO 160 film. The
photographer counts down for the assistant. After
zero, the photographer opens the shutter and the
assistant fires the flash before the shutter closes.

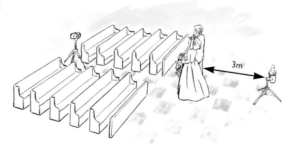

3m

Backlighting
Position the
bare bulb flash
3 metres (10ft)
behind the
couple, out
of view of
the camera.

Mixed lighting

Because most colour films are already balanced for daylight or electronic flash, you may think that to expose them in other lighting will give unsatisfactory results. In fact, it will give unreal results. But wedding photography is not solely about realism. It is also concerned with romance, magic and glamour, and mixed lighting can add to these qualities, particularly when daylight-balanced film is used.

If you are working in a church or hotel photographing the marriage ceremony, and the lighting is all tungsten, you may decide to use Type L artificial light film, which is balanced for studio floodlights. However, it is a nuisance to take another type of film, so an alternative is to stick with daylight films and use a blue conversion filter. This will require two stops more exposure, but as the subjects in this type of photo are normally still for a long period this should not be a problem. In any case, Fuji NHG11 ISO 800 film with a 80A filter will give you an operating speed of ISO 200 in tungsten light.

Too warm?

Usually, however, you are not dealing with just tungsten lighting, but with a mixture of tungsten and daylight or tungsten with flash. While this results in prints that are excessively 'warm' (orange), the final results are nevertheless attractive. Even when you are working in a room with plenty of daylight, switching on lamps in the background is useful, especially if the background would otherwise be too dark.

Too green?

Fluorescent lamps do not figure strongly at the type of venues used for weddings, but should you find yourself in a situation where these are present, the green effect they produce on daylight film can be minimized by the use of Fuji Reala professional film.

As the photographs here demonstrate, you can use mixed lighting with impunity. To have used flash on

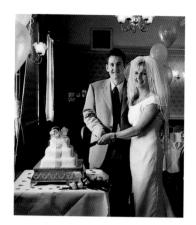

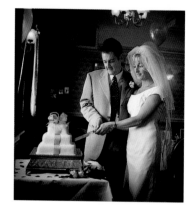

Left: A set-up
In the first shot, the couple are posing beside the cake, which is near a window; they are lit purely by daylight. The room lights, which are at a distance, have been switched on and provide a warm glow above and to the side. The photograph has been taken without any attachments. By contrast, the second shot has been photographed through a Pro-4 low-key vignetting filter. This has darkened the window side with its distractions and disguised the fact that this is a pre-meal set-up photograph and there are no guests in the background.

any of them would have completely destroyed the character of the places. The important thing is always to print them warm, rather than attempt to make them neutral. If you print neutral you will end up with blue flesh, the least romantic tint imaginable!

One of the benefits of taking some shots on black and white film is that you can safely ignore the problem of mixed light situations and concentrate on the contrasting shapes and tones created by light and shadow.

Facing page: A spot of romance
The bride is sitting on the window sill facing out, so her face is lit by daylight. Most of her dress is lit by artificial light, which causes the dress to print yellow. The wall beyond is lit by a mixture of the two and may be warmer than in reality – compare it to the window sill in the foreground. Despite the mixed lighting the finished print is attractive and conveys the character of the place. Playing around with flash on this staircase would have taken too long and the result would not have been as attractive.

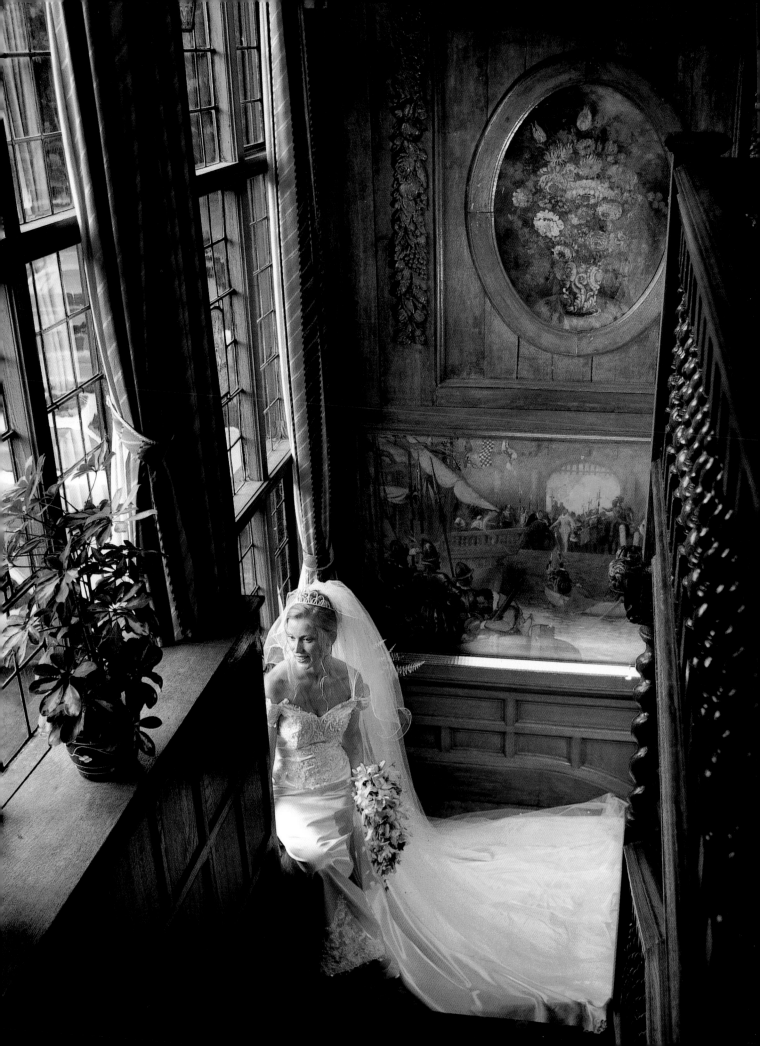

Unusual lighting conditions

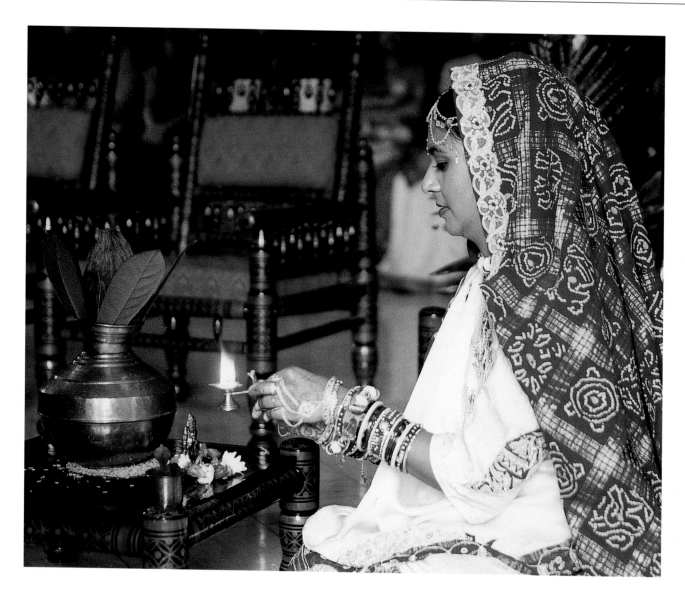

One of the pleasures of wedding photography is the fact that from time to time you are presented with unusual lighting conditions to deal with. You should always welcome these as opportunities to produce some memorable pictures. Real candles are sometimes used at church services, particularly around Christmas. Fireworks are becoming a part of wedding receptions, and the historic houses and castles used for many functions often look good floodlit at night.

There can be few hard and fast rules for variable lighting conditions, but the main thing is to not skimp on film. When bracketing the shot with colour

Above: Candle-lit ceremony
You can take atmospheric pictures by candlelight only and should certainly try it it, but it is usual to add flash. It is important that the it does not wipe out the candle, so keep the flash weak. Use a large aperture (f/4) and slow shutter speed (¹/₁₅th second) for an effect like this on ISO 400 film.

negative, however, forget about half or even one stop differences – bracket plus or minus two stops.

Candles

The wedding may be lit only by candles. On an ISO 400 film this calls for an exposure of perhaps 1 second at f/4, depending on how many candles and how far

away each one is from the people in the photo. The print will be very red, but do not worry about trying to filter this out. The important thing is to make sure your subjects stay as still as possible. Take several exposures to make sure you capture the image.

Buildings at night

It is usually best to take photographs that include a building before it is completely dark, so that you get the outline of the roof against the sky. When posing a couple in front of a building, you often need to use flash to light them. The secret here is to remove the flash from the camera and direct it towards the couple from one side. This not only avoids an excessively lit foreground, but also adds atmosphere to the picture. With some flash types you can set the flash for a

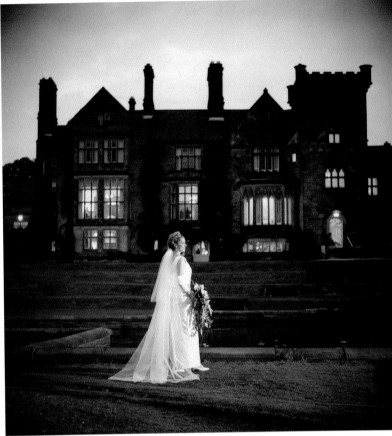

Above: Flash in the sky
A flash was held at 90 degrees to the lens at the right and directed on to the bride. A low-key vignetter helped to darken any flash spill on the grass at the bottom right. A general meter reading was taken of the scene – building plus sky gave ¼th second at f/8 – so the flash was also set for f/8 on ISO 400.

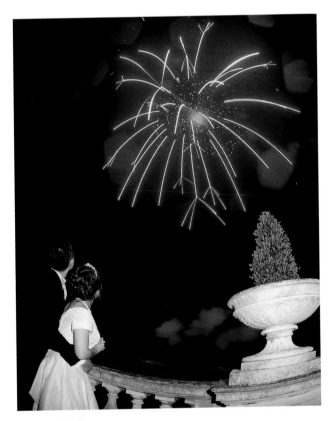

Above: Big bang
A fish-eye lens was used close to the foreground to ensure the fireworks were fully covered. Exposure of ¹/₁₅th second at f/8 was enough to record streaks from the fireworks on ISO 160 film.

narrower beam as if using it for a long-focus lens. This can also help the image. Fire the flash with either a long synchronization lead or an infra-red or radio-controlled remote device. If you have no assistant to hold the flash, you will also need a lighting stand.

Fireworks

Fireworks are extremely unpredictable. You never know when they are going to go off or where they will land, and before they begin you can see nothing through your camera. On the other hand, they do last several seconds, giving you time to locate them in the view-finder and open the shutter for one second to capture the trail across the sky. Include the bride and groom in the shot as well, and a little foreground also helps to give depth and perspective. It is best to use a wide-angle lens and put a small amount of flash on the couple.

PHOTOGRAPHIC STYLES

Wedding photography really stretches the skills and imagination of the photographer. A series of pictures has to tell the story of the wedding day from beginning to end, and the challenge is switching from one style of photography to another. In this section we examine the three main styles – formal, casual and photojournalistic – and demonstrate how to mix and match elements of each to produce an album that captures all the aspects of this special day.

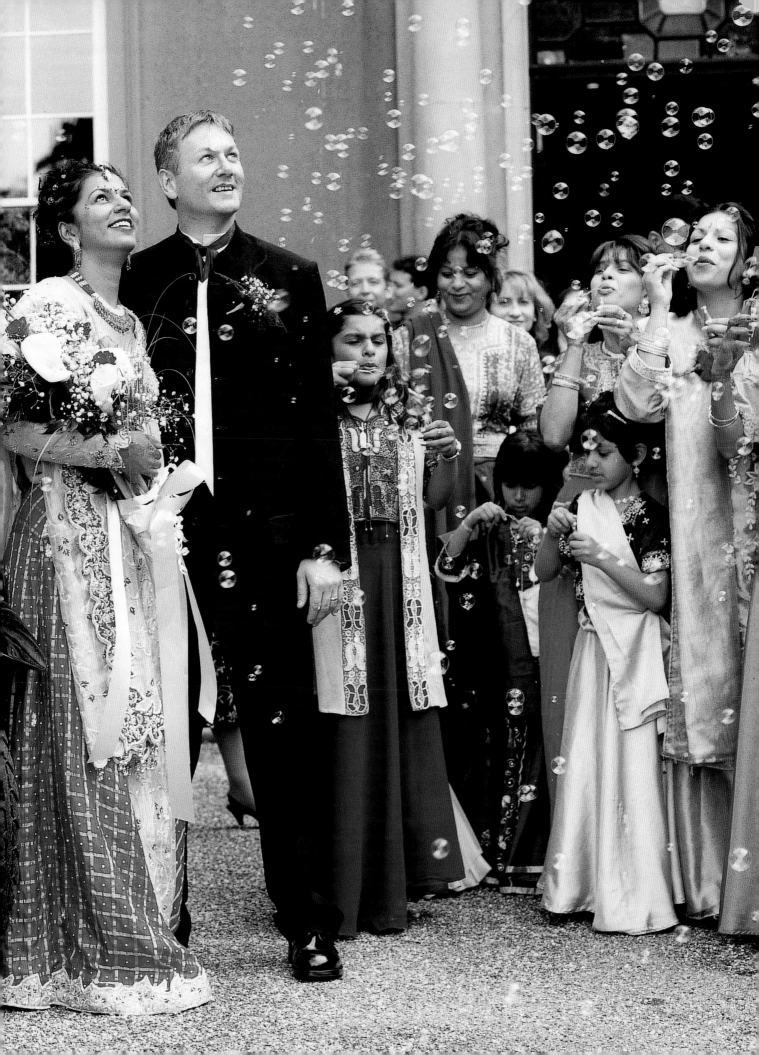

Formal portrait of the bride

It is important to include at least some posed, formal photographs of the bride as part of the wedding coverage. These shots take time to set up, to arrange the bride and to find the right setting, so you may find yourself limited in the amount of shots you can take.

Traditionally, the bride is the focus of the day. She has gone to great lengths to look marvellous – and she does. She will be wearing the most expensive dress of her life, and is unlikely to wear it again. The ideal time to take photographs is before she leaves the house: once she steps outside, a hair gets out of place and perfection is lost.

If there is insufficient space for full-length pictures in the home, take three-quarter-length portraits instead. With careful planning you can ensure most of the detail of the dress appears in the shot. People tend to be more relaxed when posing for three-quarter-length shots, so it is easier to get a good picture and also helps to ease them into a day of photographs.

If time is running short you may have to wait until after the ceremony to take the formal portraits. At least two versions are required, full-length and close-up. The dress will have been designed to look good from all angles, so the full-length should show the dress and train and the close-up should capture the details. Formal does not necessarily mean a stiff pose and unsmiling expression. However, there will be many cheerful images during the day, and a few faces uncreased by smiles will provide a welcome contrast.

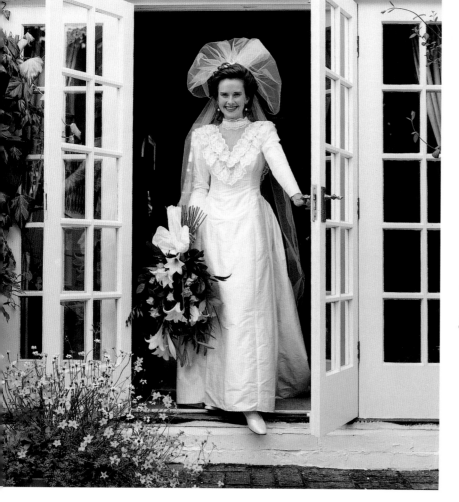

Left: Balancing the shot
This is a very square-on portrait, but the jutting foot, bouquet and hand on the door all break the symmetry. The dark background interior shows the veil to advantage, while the almost black-and-white effect is pleasantly relieved by the colour of the foliage. The yellow in the bouquet finds an echo in the garden.

'The dress will have been designed to look good from all angles'

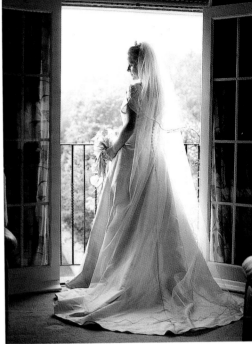

Above: Using window light
This photograph was taken with no
fill flash. The bride is in true profile,
with her body angled away from
the camera to show the rear of
the dress through the veil. Light
reflected back from within the
room illuminates the side of the
dress in the shadows, revealing all
the delicacy that would be lost
when seen in full lighting.

Above: A solemn moment
While this image can in no way be
defined as a formal portrait, it
provides a further example of
extending your coverage to include
the whole range of moods, express-
ions, detail and significant activity
that will occur during a wedding.

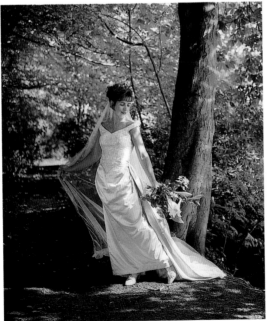

Right: A classic pose
This photograph displays the dress
to advantage. The bride stands
with her weight on her back foot
at the edge of the sunlight, which
just catches her face, flowers and
train. Placing the main area of the
dress in shadow reveals the detail,
while the dappled sunlight adds
texture to the shot.

Calculating exposure

To calculate the exposure
required for a mainly white
subject, i.e. a bridal portrait,
take an incident light reading
by holding the meter beside
the face and pointed towards
the camera. Alternatively, a
spot meter reading can be
taken off the face.

Formal portrait of the groom

Usually the bridegroom is photographed at the church or wedding venue before the bride arrives for the ceremony. As with the bride, you need to shoot a formal portrait of the bridegroom in his wedding attire. He will often be wearing something he is unaccustomed to, so it is important he looks at ease in his clothes. Full-length portraits of a man are difficult unless you have an appropriate setting; some men feel uncomfortable standing upright in an empty space. It is often better to take a three-quarter-length picture in which the groom can lean on a gate or wall, or at least have his out-of-shot foot raised on a step or even a camera case. This will enable him to lean forward on his knee, creating a more natural pose. Try to avoid direct sunlight by working in shade so the groom doesn't have to squint and his skin looks smooth.

The bridegroom will probably feel more at ease being photographed with his attendants, and these should follow next. Good composition from full-length portraits is easier with several people in the shot. The poses can be relaxed and the bodies in a group should overlap to unify the photograph.

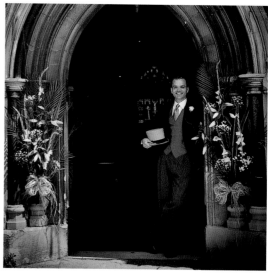

Above: Providing a frame
Even though, potentially, there is a lot to distract the eye from the groom in this picture, it works well as a full-length photograph because of the framing provided by the decorated porch. The pose is more attractive than if he had been standing in the centre of the door.

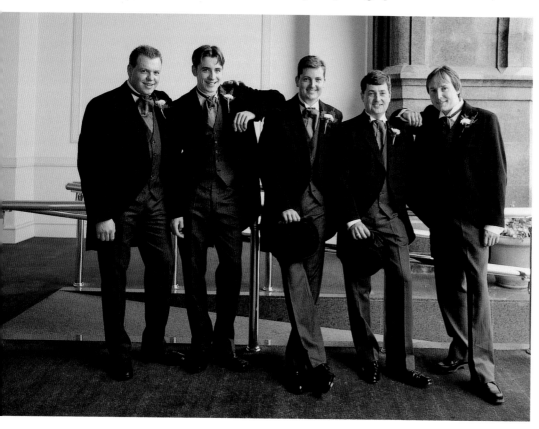

Left: Unifying the group
Here, the railing gives the men something to lean against for more relaxed poses. With their arms casually resting on each other's shoulders a connection is provided between the figures.

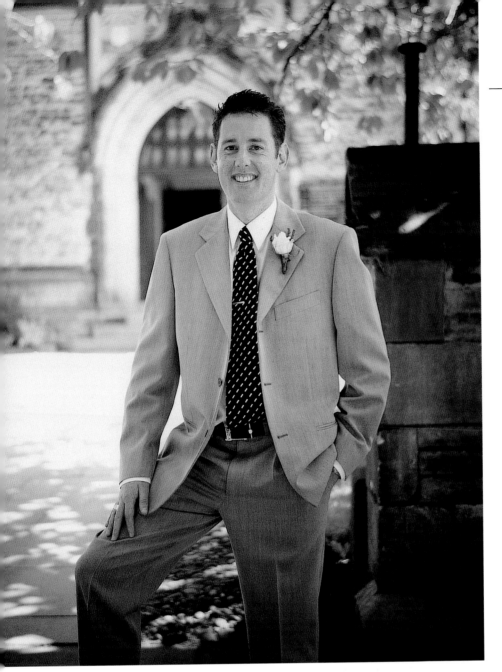

Left: Keep to the shade
The groom's right foot on the photographer's camera case balances this pose nicely. Note how the church door provides the background – an utterly appropriate setting. The shaded location provides good lighting for his face, and care has been taken to ensure that the sun was not dappled on him.

Below: Something to lean on
This lych gate provides a handy posing bench for the two men, offering them a place to lean their bodies foward slightly and creating a base for the image. The shade provided by surrounding trees protects them from direct sunlight, resulting in relaxed and easy facial expressions.

'Full-length portraits of a man are difficult unless you have an appropriate setting'

Formal portrait of the couple

The wedding coverage is not considered complete unless you have a celebratory formal first picture of the bride and groom immediately after the marriage ceremony. This can be taken within the church or marriage room or in the doorway as they leave. Take at least two photographs, a full-length shot and a three-quarter-length.

As they emerge from the doorway they will either be holding hands or the bride will be holding the groom's arm. When posing together for a photograph they will often put their arms around each other, but they should be disentangled from this position as it pulls at their clothing and spoils the image!

This is a formal picture, so pose the couple slightly: ask the bride to hold the bouquet with her outside hand, and the other hand can be placed behind it. The groom should place his inside hand just in the centre of the bride's back so that his arm is not stretched. Standing at a slight angle to each other with their

Include the door frame

If the couple is emerging from a doorway, do not go too close and lose the door frame, leaving a black hole behind them. When photographing from the side, it is usual to do so from the bride's side so she is the one nearest the camera. If they are photographed with the bridegroom closest to the camera, he will look taller. This control of perspective can be used advantageously to modify actual height or size differences.

weight on the inside foot and their outside foot slightly forward, they will lean in towards each other naturally.

Pictures of the couple emerging after the ceremony must be taken quickly; there is a queue of eager guests behind them who do not take kindly to being held up inside. Determine the exposure and viewpoint before the couple come down the aisle, and three frames can be taken in a matter of seconds once the couple's pose has been checked and modified as necessary – one with the couple looking into the camera, one looking at each other, and a closer view taken slightly to one side.

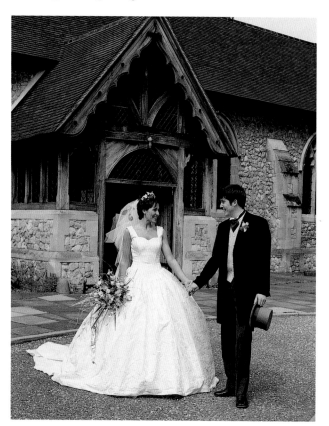

'Take at least two photographs, a full-length shot and a three-quarter-length'

Left: Include the venue
At a church wedding it is important that the venue be seen in the picture. Here, the photographer has brought the couple outside so that he can get the porch in view. The bride and her veil are carefully positioned against the dark interior for clarity.

Facing page: Avoiding sun
Here, the sun was strong so the photographer left the couple just inside the door, softly lit. The doorway itself is not lit symmetrically so the picture has been taken from one side. We can just see the best man and bridesmaid behind; this is fine at this stage – they are part of the story. There will be time later to take the couple alone.

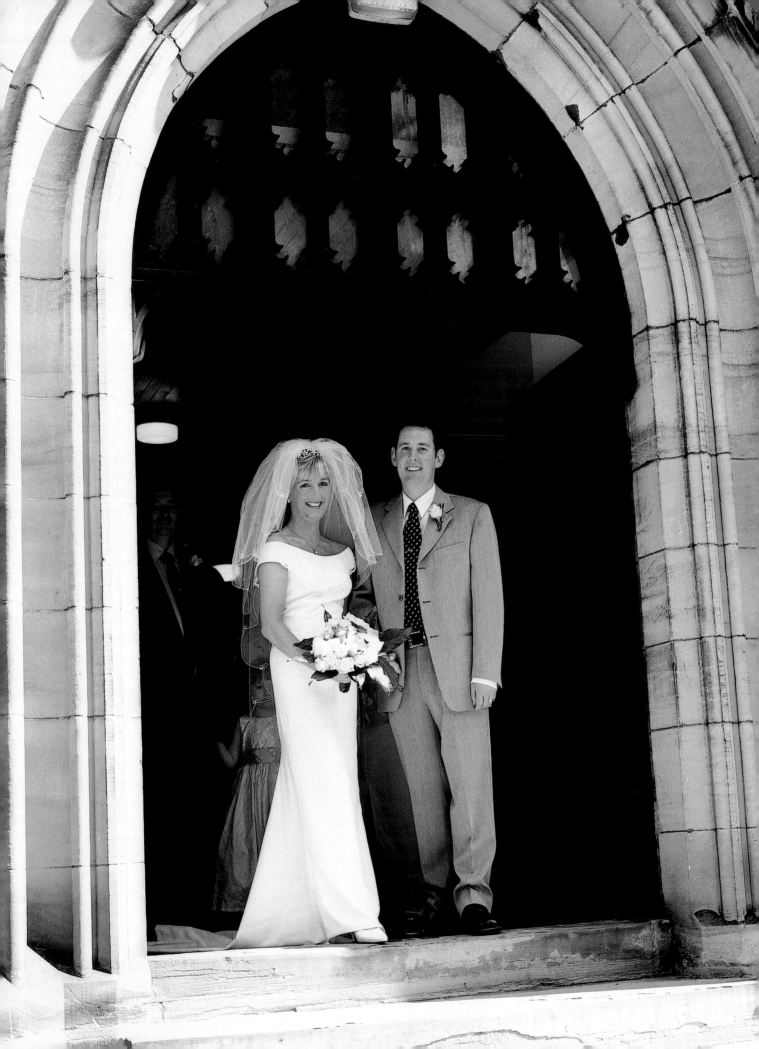

Alternative pictures of the couple

Most of the photography at the wedding will include the bride and groom: activity pictures in which they are involved and portraits which also show the setting. These all help to tell the story of the wedding, but is important to also take portraits that show the couple without too many other elements.

A portrait of two people together should have balanced composition; this usually requires their heads to be on different levels. An easy way of controlling this is to have one or sometimes both of them seated. If the bridegroom sits on a wall or the seat of a bench he is at a height at which the bride, usually shorter than he is, can place her arms around him and get her head close to his.

These poses often include hands as a way of showing the rings without the bride and groom having to pointedly hold their hands towards the camera. But when working like this it is important that the hands are not nearer the camera than the faces or they will appear too large. A longer focal length lens helps control perspective and also aids the out-of-focus background. Ask the couple to smile, but aim to show contentment rather than wide grins.

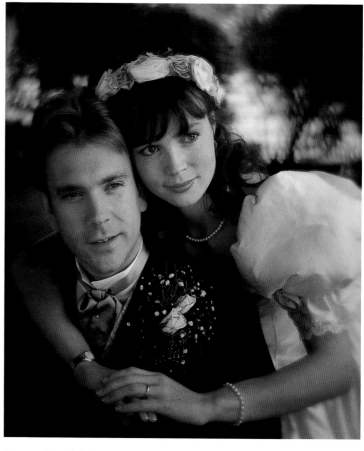

Above: Soft lighting
Taken in shade the lighting of this photograph is soft but directional, the perfect light to flatter the couple. The bride's arms link the couple, and we see her ring. A light diffuser over the lens smooths their skin and produces the effect of movement in the out-of-focus background, an attractive effect that enhances the image.

Right: Not yet united
Once the couple are married the pictures should depict them as a unit, as in the examples above and opposite. Beforehand they are two individuals and although this image is weak in design terms, it is very strong in story-telling.

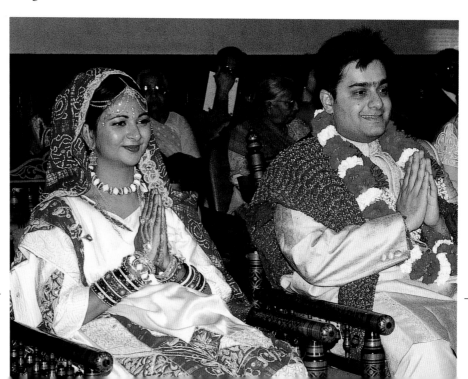

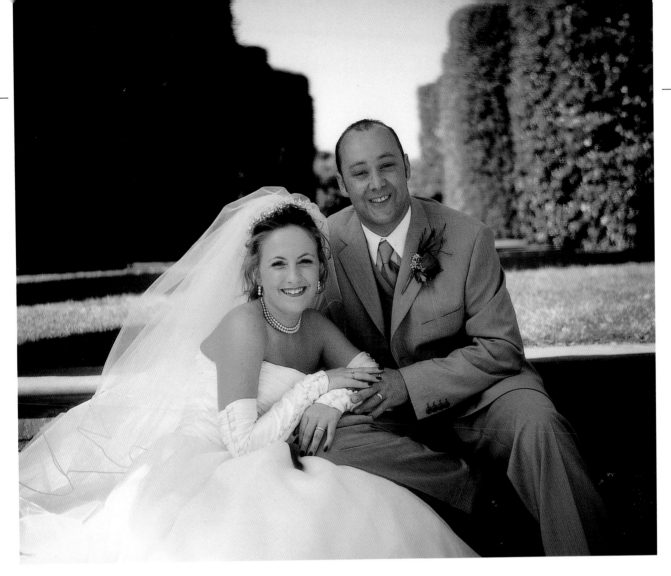

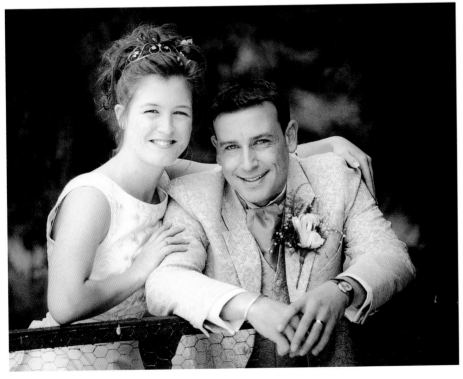

Above: Using steps
Sitting the couple on different steps is an easy way of getting the heads at different heights. Here, the photographer has been able to use a narrow area of shade, which gives beautifully diffused light. Note how the bodies lean together and the areas of the two are balanced by placing the bride slightly in front of the bridegroom.

Left: Removing background
In this photograph, a gate provides a prop to enable the groom to be lower than the bride. Taken with long focal-length lens, the background disappears altogether, producing a very simple, direct wedding portrait. The smiles on the faces of the couple are cheerful but not too wide.

Groups with attendants

Two or three formal groups are mandatory at even the most informal wedding, while some families expect a quite a number. It must be made clear to them, however, that it takes several minutes to gather people together for each shot – and time spent on group photographs means less time for other photographs or time spent with guests. Naturally you will photograph the bride and groom with all their attendants, and the couple with both close families. This may be extended by adding the couple with the bridesmaids and best man, and the couple with all the parents. Some will ask for each whole family and one with friends. However many you take, the procedure is the same: start by posing the couple and then add the other members of the group.

Some people may think families should be posed according to a hierarchy. This is irrelevant in creating a good group photograph, and people should be positioned according to their size so that you achieve an attractively shaped group. Usually you will ask the group to stand, but if there are too many people for a single row and suitable benches or chairs are available, you can use these to create several rows of differing heights.

Building a group photograph

1 Pose the bride first, then the bridegroom, who should be standing partly behind her. Next, place the best man beside her and add the chief bridesmaid next to the groom.

2 A group of four is the hardest to arrange attractively. If everyone is of a similar height, you finish up with virtually a square because the width of the group will equal the height.

3 Although the proper place for the train of a dress is behind the bride, this type of photograph is the one instance where it can legitimately be pulled to the front if it is long enough. If the train is left round the back it will be completely lost from view. The train can be used to balance the composition of the photograph by positioning it to one side of the group.

4 If you are working indoors you will have seating available, which makes attractive grouping easier to achieve. You can create differing head heights by placing some people on the seats of chairs and asking others to perch on the chair arms or leaning agaist the chair backs. A good basic rule is to have shorter people standing and taller ones sitting, so the gap between the heads is minimized.

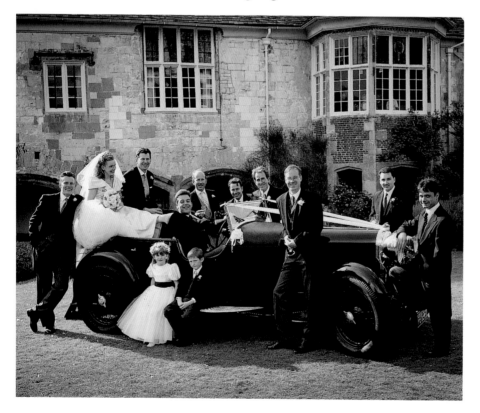

Left: Grouping around objects
If you have a notable feature like the vehicle here, or a particularly suitable location, the group photograph can be built around it. This method features the faces of everyone involved, but does so in a more interesting manner than a line up. Semi-backlighting separates each person from the building and the background.

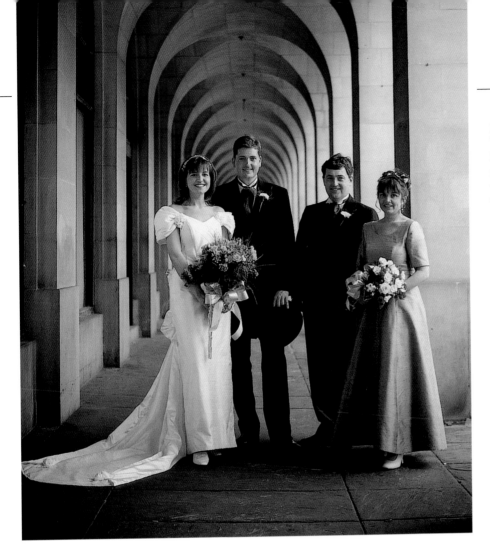

Left: A simple group
This illustrates the basics of building any group. Should the two men be together and the women at the ends? The answer here must be yes. By placing them in these positions, the photographer finished up with a well-designed group, their heads forming a curve which echoes the arches above them. Any other positioning would be less attractive in this setting.

'start by posing the couple and then add the other members of the group'

Right: Combining styles
This is a good example of the combination of formal and casual styles of grouping in a single picture. It has the symmetry of the former and the posing of the latter.

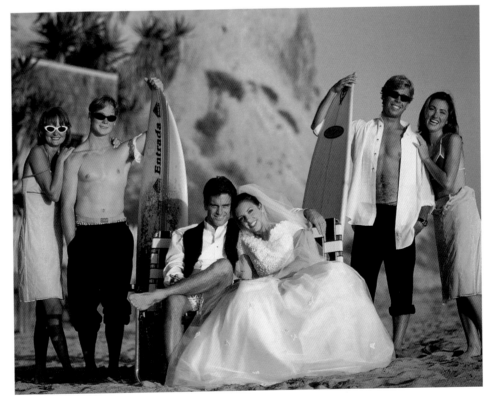

Family groups

Similar rules apply to both family groups and groups with the attendants. Living in an era where many people have step-parents, step-siblings and half-siblings in addition to their brothers and sisters, trying to organize groups can be a logistical nightmare and must be planned beforehand. It is also very tempting to find a suitable setting and then shoot all groups in the same spot. It can certainly be quicker, but it makes the album more interesting if alternative backgrounds can be found for at least some photographs, especially if the venue offers a number of different spots.

One problem for the photographer is working with bright sunshine which causes squinting and shading on faces. One solution is to pose groups in the shade. This may result in the background features being lost in shadow, but always remember this is primarily a picture of the group – the background is purely the setting.

Below: Creating a pleasing shape
This group comprises the parents, the bridesmaids and the best man. The mothers are on the bench ends with the fathers beside them and a bridesmaid at either end. A sophisticated series of lines has been created by balancing each person with another.

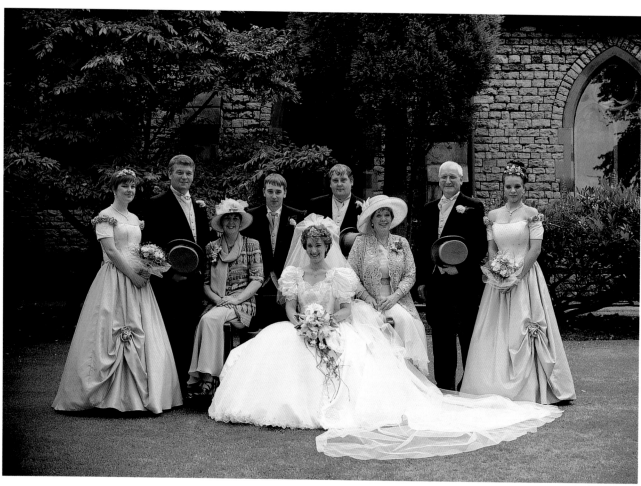

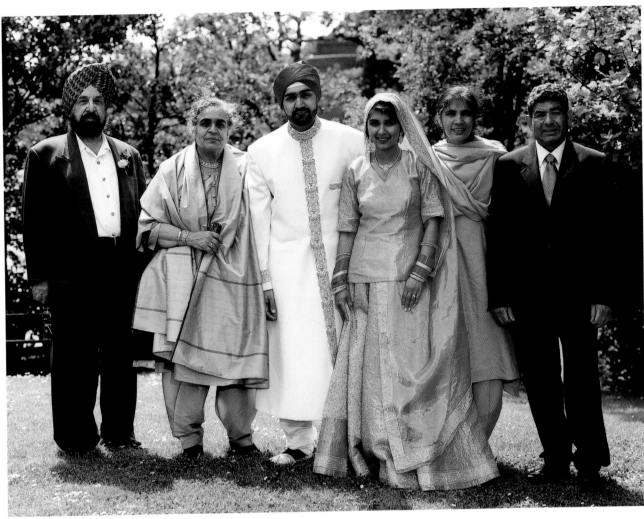

Above: A group before you refine it

This is how groups often assemble before they're organized. The groom is leaning away from his bride instead of towards her and most of the people are square-on to the camera. They need turning in slightly which will flatter them and give a little more space around the group. The overlapping also needs changing: if the man on the right stands partly behind the woman beside him, we shall see more of her and less of him which will provide better balance; the tall man on the left needs to be moved slightly behind the woman on his left.

Right: Work against the light

This shot has been photographed against the sunlight. Although the small details visible in the background will have some meaning for the family, it is the lighting that is the strength here. The picture works especially well because the light-coloured ground ensures there is sufficient illumination reaching the faces. Note the positioning results in a simple curved line of heads.

The big group

The aim of a large-group photograph is to ensure that everyone can be seen. To simply take it on the level with everyone in a long line, or worse, people bunched behind each other, is a waste of time. Photographers used to fight shy of taking a big group, but in fact it is a vital part of every wedding and it relieves you of taking endless shots of smaller groups. This sort of image ideally fits a panoramic double-page spread which wil be large enough to show everyone. Remember to place the bridal couple just off-centre so they are not lost in the crease of the album!

Look out for a verandah, steps or even a slope that you can build the group on. Or you can take the photograph from a high viewpoint, such as a first-floor window, a fire escape or a flat roof. Prepare ahead for this: do not expect to just turn up and be handed the keys to a bedroom overlooking a garden. A step ladder is also useful, but make sure you have someone holding it steady!

A useful time to take the group picture is just before the bridal party go in for the receiving line. You may need the help of the toastmaster to gather everyone together.

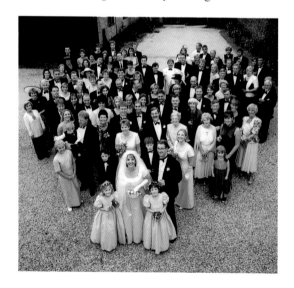

Left: Group with children
For this group the bride and groom have been brought forward with the young bridesmaids. The image now fills a square shape – ideal for a single album page. You will never get everyone in the group looking at you at the same time, but if you keep the patter going you will retain the attention of most.

Above: Group with lake
In this format the group is fan-shaped, symetrically positioned between the trees. Here, the bride and groom have been positioned marginally just to the right of centre to avoid eventually being divided by the centre crease in the photograph album. The centre line actually goes through the fountain.

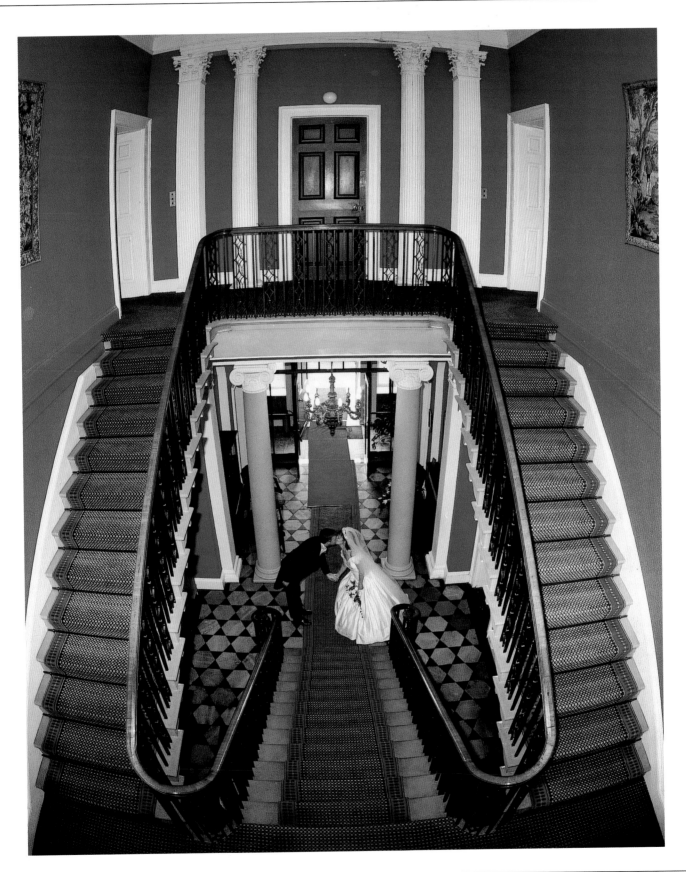

Let the setting suggest images

Y̶ou are at the wedding to photograph the people, and much of the photo-reportage work is concentrated on capturing the couple and guests and their spontaneous expressions. Often, however, the settings themselves suggest pictures that can be more relaxed than formal portaits and can be included as an additional element to the coverage. You do not need to include the whole of a building or feature, but there should be sufficient shown in a shot to reveal the unique characteristics of the venue. The key is to carefully select the background: you do not want too much fussy detail which will distract the eye from the people in the shot, but you need enough features to provide a certain atmosphere. Another important consideration is the lighting, but as these are staged pictures you can control it to create the right effect.

'reveal the unique characteristics of the venue'

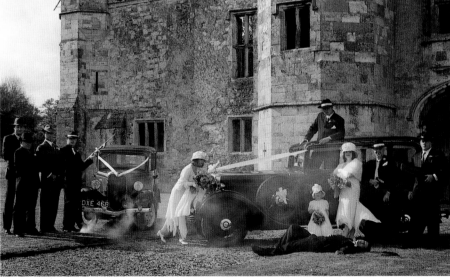

Left: A gangster gunfight
Some couples go to immense trouble to set up themed weddings. This couple dressed their guests as gangsters from the 1930s, and the photographer has captured their play-acting at its pinnacle as one of the guests is apparently murdered!

Signing the register, cutting the cake

Nothing taxes the ingenuity of a photographer at a wedding more than the signing of the register. All too often they regard it as a chore to be got out of the way as quickly as possible, when they ought to see it as a challenge to be overcome. Mandatory at every type of ceremony, the copy of the entry is the one tangible item the couple receive to show that they are officially husband and wife. Almost without exception the couple want a picture of the signing, but all too often the registers are signed in a dismal, cluttered vestry where you have few options for your viewpoint. Many clergy insist that the photographer waits until the official work is over and instead stages a mock-up afterwards. Others conduct the signing during the singing of three verses of a hymm and insist that the photographer take all the shots required during those, even though it can take time to find a viewpoint. Registrars at civil ceremonies also usually ask you to wait until they have finished the formalities.

Although most vestries and churches are dark, you will get a more atmospheric picture by avoiding flash and just using the available light. It will also help to hide any distracting background detail.

It is standard practice to take a mock-up picture of the couple with the cake before the meal with just the photographer and the couple in the room. This is a good idea because you can position them for the best lighting, and it provides a record of the cake itself — another expensive item. They should be posed according to whether they are left- or right-handed and, as with the signing, they really should be seen looking at the cake while wielding a knife! It is more authentic than grinning at the camera. Another reason for taking this picture is that usually the photographer leaves at this stage and will not be present at the actual cutting at the end of the meal. When taking this shot, care should be taken not to show empty tables. If the photographer has stayed through the reception he or she can photograph the cake cutting for real, but if a mock-up has already been taken, it allows for the oppportunity to take alternative pictures, perhaps capturing the guests in the background.

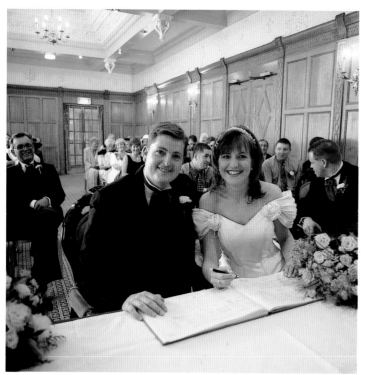

'Nothing taxes the ingenuity of a photographer at a wedding more than the signing of the register'

Left: A staged signing
Here, the signing takes place in the same room as the ceremony. The guests behind add to the atmosphere. The photographer staged this and took two views — one looking down at the book and a second looking at the camera. There is really no need for the second; if you are signing something you look down at it, but couples like, and buy, both versions.

PHOTOGRAPHIC STYLES

Above: Cutting the cake

As with so many situations avoid flash if possible. Here it would have killed the atmosphere. The benefit of taking a staged shot is that the couple can be elegantly posed with the bride nearest the camera. Regard the couple and the cake as a group of three when composing the picture.

Using a vignetter

When photographing the signing of the register it can help to use a dark vignetter on the lens, which darkens the corners of the shot and emphasizes the register itself. Working with available light indoors may require the use of a tripod. This shouldn't be a problem as long as there is space, but if you want to avoid it fast film (ISO 800) can help a lot. A mixture of daylight and tungsten adds to the atmosphere, and the use of flash would ruin the textures created by the play of light.

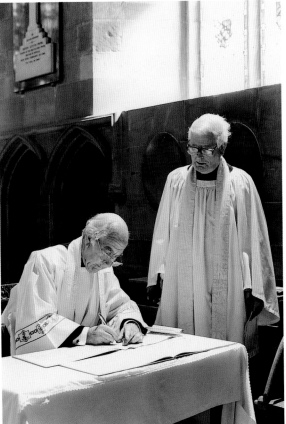

Above: Including guests

This picture indicates that the photographer did indeed stay for the reception and has had the opportunity to photograph the actual cutting of the cake. The guests are seen with their cameras at the ready, giving an interesting additional perspective of the wedding.

Left: Clergy sign too

It is not only the couple who sign the register — the clergy sign also. But why two clergymen? There is probably a family connection with one of them, so the couple will appreciate a picture. This shot was taken unobtrusively, without the subjects being aware, and the natural light creates an atmospheric shot.

Photojournalistic style

The latest style of photography to be in demand at weddings is called photojournalism or photo reportage, and it is usually undertaken in black and white. Traditional colour pictures are still very important, and some photographers see photo-journalism as an opportunity to sell black-and-white shots as an addition to the standard colour coverage.

There is a very fine line between photojournalism and snapshots. The latter are taken at random at an event, often without the photographer being aware of what is in the background of the picture or the composition as a whole. All too often the image contains too much that is irrelevant to the main subject. The important feature of photojournalism is, in Henri Cartier Bresson's words, 'the decisive moment'. Taking the photograph at the right moment is a skill achieved through lots of practice and with an understanding of people and how they react.

'The important feature of photo-journalism is, in Henri Cartier Bresson's words, "the decisive moment"'

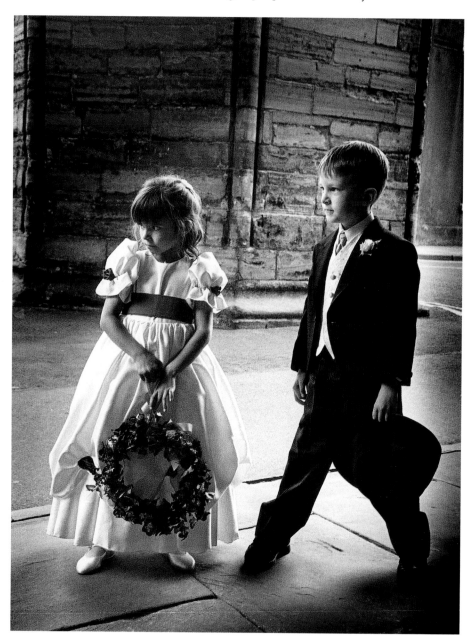

Right: Absorbed in the day
Children are a great source of inspiration for journalistic-style pictures. This example illustrates the essence of a good photograph: no extraneous elements, two children unposed, standing perfectly naturally, with their attention fixed. This would make an excellent right page for the wedding album, with a complementary image on the left.

Capturing the moment

Capturing the perfect moment at a wedding is extremely difficult. The shutter has to be released in that vital fraction of a second when everyone in the frame happens to be in position and has an expression that contributes to the overall effect. Another second either way and you capture an entirely different moment.

It is tempting to try and give a formula for capturing the moment, and indeed you can advise photographers about anticipation and preparedness, but ultimately it comes down to that impalpable quality – instinct. You have not only to observe the scene before you, but also to feel the emotion around the people. At the same time you mustn't be so drawn in to the events as to forget what you are there for. It is no coincidence that the great masters of this style tend to use cameras like the Leica, which are not only small and very quiet but also do not require flash. They move around silently, brain alert and finger at the ready, witnessing the occasion, listening, watching, sensitive to what is happening in one instant and expectant of the next. Each part of the wedding day, such as the arrival at the ceremony, the ceremony itself, the line-up at the reception and cutting the cake, presents its own opportunities.

It's essential to capture the setpiece moments of the day, but it is also a good idea to wander through the crowds and look out for other off-the-cuff moments. Keep alert during the reception as guests greet each other and enjoy a drink. Even between taking the formal shots you'll spot some lovely moments if you have your camera at the ready. In each case the tactic is the same: see the potential, anticipate the picture, frame the shot and await that crucial fraction of a second.

'wander through the crowds and look out for other off-the-cuff moments'

Below: What are you up to? It is the middle of a long service, and the child is getting restless. Sooner or later she will turn to look at the photographer at the back of the church. Luckily the mother and child are caught in a shaft of light, and the picture is balanced by the out-of-focus bride and groom in the background.

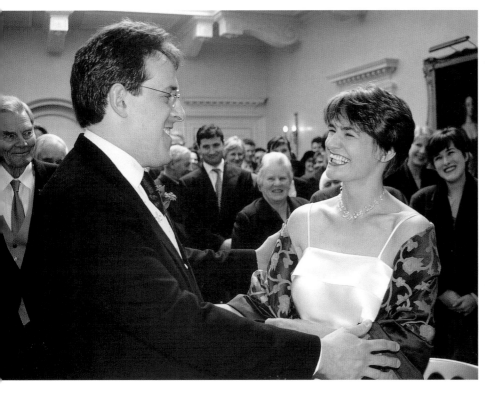

Left: See beyond the subject
Not only are the bride and groom
captured well here, but so are all
the guests, particularly the man on
the left and the woman on the right
who balance the picture. They are
not just background, but an integral
part of the whole shot.

Composition

Good design and composition is just as important a part of photojournalistic pictures as it is of traditional, posed photographs; however, it is achieved in a different manner. For formal shots the setting is chosen first and then the people are placed within it and arranged so that the group is attractive in its own right and is also complemented by the background shapes, colours and tones.

'Your first objective is to see the main subject, but take a good look around to select just the right amount of background'

Wedding photojournalism is all about capturing the moment – an incident or expression that tells a story. Your first objective is to see the main subject and capture the actions, but take a good look around to select just the right amount of background to include.

As well as observing through the viewfinder, look around with the naked eye and you might spot useful complementary features outside the view of the lens. Include sufficient background to add to the composition, but be careful to avoid extraneous details that may distract from the shot. Photojournalism is all about working quickly and getting a balance between capturing the moment and good composition. By developing a feel for composition and learning to work rapidly, you'll soon be taking exciting off-the-cuff shots.

Above: Last-minute repair
The bride checks her make-up while the bridesmaid adjusts the veil. To be meaningful, we need to see where these finishing touches are taking place to put it into context. It is important to include a sufficient part of the car to do this, and the white ribbon on the left confirms this is in fact the wedding car. Reading the picture from left to right, the eye is led from the ribbon along the chrome window frame directly to the bride.

PHOTOGRAPHIC STYLES

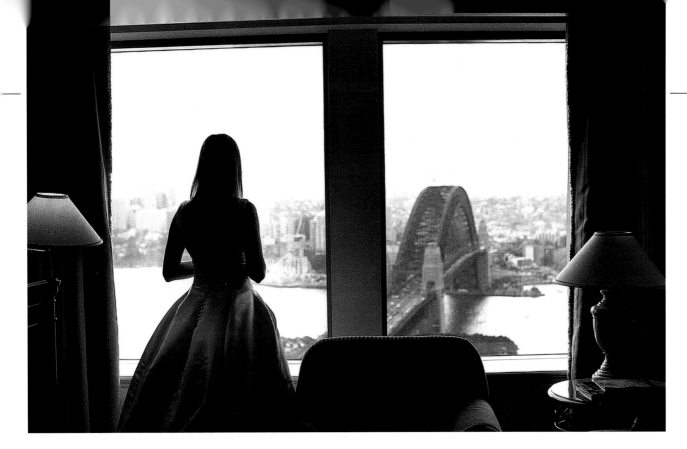

Above: Look for symmetry

The photographer entered the bride's room in a hotel overlooking Sydney Harbour, saw this photograph and took it immediately without any instruction or re-positioning. In an almost symmetrical design, the silhouette of the bride is neatly echoed by the shape of the bridge and the lampshades at either side.

Left: Two make one

Having two main subjects in a picture, one at each side of the frame, sounds like a disastrous design, but the look between the two children creates a single subject. The distance between them depicts the disdain that children of this age have for the opposite sex, so the storytelling is strong. They are linked not only by the bench but by the limited light area of grass above it. The low viewpoint has provided this, and the larger dark area above keeps the eye firmly on the children.

Special techniques: black and white

Monochrome pictures have become mainstream again, with a new generation of photographers discovering the creative opportunities of black-and-white photography. Clients seeking something different, who have been brought up on colour school photographs and family snapshots, often request a selection of black-and-white shots of the wedding day. If you decide to produce black-and-white images, there are two aspects to consider – the technical limitations and what you would like to achieve aesthetically. There are three methods of creating black-and-white prints: each one has certain advantages and disadvantages which are outlined in the box on the right.

Routes to black and white

1 Take all photographs on colour negative film without worrying about the final outcome. With this method, only at the printing stage do you need to decide if you want black-and-white or colour prints.

+ Only one film to think about, which saves time.
+ No possibility of using the wrong film.
+ No time wasted on deciding which format to use.
+ Allows the couple complete flexibility when choosing shots for the album.
− Prints need to be produced on special colour-sensitive paper.
− The quality of the final prints is not quite as high as other methods.
− Developing has to take place in a laboratory.

2 Take black-and-white images on conventional black-and-white film and print on black-and-white paper.

+ There are lots of different black-and-white emulsions to choose from for particular effects – from low-speed fine grain to very high-speed grainy emulsions.
+ You can use your own darkroom for production.
+ Very high-quality prints are attainable.
+ Black-and-white prints can be toned in a variety of colours and true archival prints produced.
− Each type and speed of film needs individual processing times; this service is not available from all laboratories.

3 Take black-and-white images on chromagenic black-and-white film which can be processed in standard colour negative chemicals (C-41) along with colour film. Kodak T-MAX Black-and-White T400 CN and Ilford XP2 are the two in most common use.

+ Creates a high-quality, fine-grain image from fast (ISO 400) emulsion.
+ Prints can be processed by any laboratory with standard C-41 process.
+ Images can be printed on black-and-white paper for finest monochrome images, or on standard colour paper processed in RA-4 for expediency or special effects.
+ Sepia-effect or any other monochromatic image colour is obtainable by printing on colour paper.
+ Prints can be made in a home darkroom with standard materials.
− But more suited to laboratory film processing than a home darkroom.

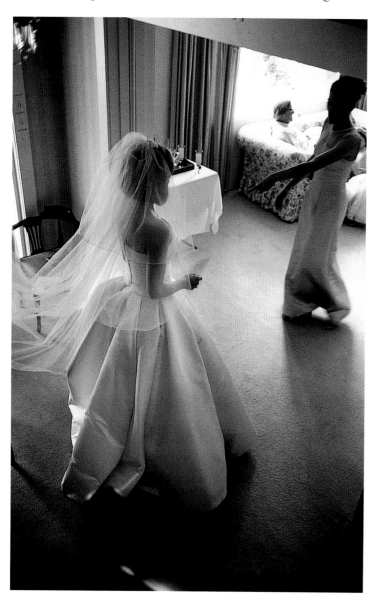

Left: Avoiding distractions
In colour this could be a very messy shot, with the important elements – the girls – appearing very dark and the eye distracted by the colour in the walls, settee and carpet.

Working quickly

The most frequent complaint you tend to hear about wedding photographers concerns their speed of working. 'The wedding photographs are superb but, oh, the photographer was so slow,' is said time and time again.

The photographs were superb, of course, because the photographer and assistant took the trouble to make sure that the groups were tidy and the bride and groom ended up with a comprehensive selection of photographs, showing not only what they did and saw on their wedding day, but also included many aspects of the day they may not have seen first-hand.

Quick work and planning

Doing your homework beforehand will enable you to work as quickly as possible. Many different types of photographs are now required at weddings, and fitting them all in requires planning. People tend to request fewer pictures of family groups now, and one large group photograph normally takes care of the rest of the guests. The portrait session with the couple often takes longer than it should, simply because the wedding venue abounds with attractive locations which both photographer and bride cannot resist using.

Helping the couple enjoy their day

Some couples request that all the photography be carried out as casual, unarranged shots. However, this is simply not feasible if the coverage is to be done properly and to the satisfaction of all parties. It is possible to let the couple spend most of the time with their guests if they are willing to work with you to fit the photography in during a few dedicated sessions. Now that many weddings take place in a hotel, the families often dress there and can be ready long before the actual ceremony. This is an ideal time to take the family portraits – not just the bride's family, as you would at home, but the groom's family too.

Although superstitions die hard, some brides are willing to meet the groom beforehand for photographs, and a number of portraits can be taken then, saving valuable time later.

Assistants

Having a good assistant is a great help when trying to work quickly. It takes time to train someone, but it is worthwhile persevering with the same person who will learn to know what is required of them. Such duties may include:

• Carrying the camera case(s) and accessories ready to hand to the photographer as required.
• Reloading camera backs and checking camera functions.
• Holding reflectors and diffusers for portrait photographs.
• Keeping a lookout for arrivals.
• Assembling people for the next group shot while one is being taken.
• Moving guests out of shot who have strayed into the background.
• Running forward during the group shots to adjust clothing and posture on the photographer's direction.

• Watching for unwanted items in the background of a picture (camera cases lying around are a common example).
• Holding a remote second flash.
• Holding an umbrella over the photographer on wet days.
• Getting the photographer's car ready for a quick departure to the reception when appropriate.
• A fully-trained assistant may also take supplementary photographs while the photographer is preoccupied, or provide alternative views of certain moments, for instance the arrival of the bride at the church.

Time-saving tips

■ Pre-plan where you would like the wedding cars to stop.

■ Check that the cake knife is in place before you get to the cake cutting shot.

■ Arrange for the bellringers to have a ten-minute break soon after the couple have left the church; trying to make yourself heard over bells is almost impossible.

■ Take your group shots at the church doorway as the couple come out – the wedding party are all there, conveniently in line: attendants followed by parents.

■ Try and take the couple to a quiet part of the garden for portraits where they won't be distracted by guests.

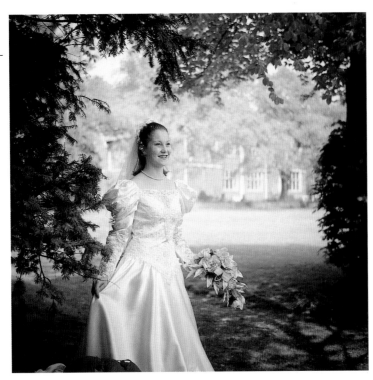

Left: The gardens
When working in extensive grounds where you would like to see the buildings in the background, it is useful to have an assistant to run around and move garden furniture and other items out of the way. Retouching extraneous objects out later would prove very expensive.

Below: Large groups
Photographing all the guests as a big group can take a few minutes to arrange, but not as long as a taking a whole series of smaller groups. An assistant is invaluable at this point to move people around to your instructions. Here, a fish-eye lens has been used.

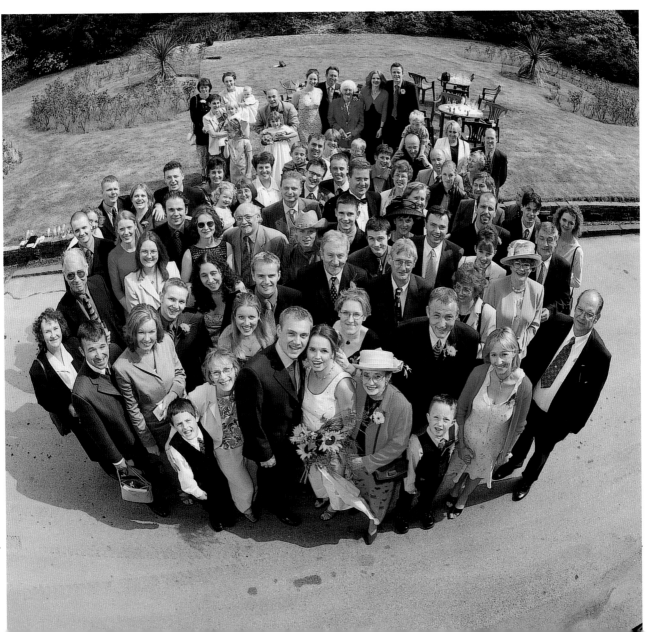

What if it rains?

Some weddings occur on a warm, dry summer's day in a beautiful countryside setting, and everything goes according to plan. However, just as many take place when it is pouring down with rain, in the dark and cold, with unappealing indoor locations.

No let-up?

If it is one of those days when there is little sign of the weather brightening up, accept it – nobody likes standing around in the rain. If you hadn't planned to go to the bride's home, now is the time to arrange to see her there for some portraits before the ceremony. Even if your contract does not include it, make the offer, if you do not take photographs you cannot sell them.

Before the ceremony arrange with the officiant to take some set photographs in the church or wedding room once the couple are married. Use flash combined with the available light and take the main family groups in front of the altar or other appropriate locations.

There may not be much space at the reception. The dining room is likely to be filled with tables for the meal and the bar area full of guests. If you go to the hotel before the wedding and discuss the weather problem with the manager, you may find they will provide another room or rope off an area for photographs.

This is a good time to rig up some mains flash for your groups – one lamphead with a large umbrella and one lamphead behind the group – and borrow any items of furniture and flowers that may be useful. The staff will have much more time to be cooperative before the wedding party arrives, soaking wet.

If the venue has very poor settings, take a portable background with you. You can get quite large ones that work on the sprung ring principle (like reflectors), and these are quick and easy to assemble.

Very hot, sunny days bring problems too. You may be tempted to work in an air-conditioned hotel rather than under a blazing sun, which means you can photograph the men with their jackets on.

Left: Backgrounds
Be prepared to carry a studio background and a couple of mains flash units with you on wet days and set up a 'studio' in the hotel. With no settings to add variety, however, you will have to be imaginative with your posing.

All steamed up

One of the problems with wet, and also cold days, is that your lens and viewfinder become steamed up as soon as you enter a warm room. It is a good idea to take a small hairdryer with you for just such an occasion. Mop off the excess condensation, and then use the hairdryer to dry everything out.

Facing page: Venue and guests
It is important that even on wet days the wedding coverage shows not just the wedding party but the venue and their guests. An easy way to incorporate both is in a picture like this, taken just before the meal. Do not delay it – once the meal has started the tables become cluttered and untidy.

Left: Use the furniture
Photographing families in a hotel means that at least you have plenty of furniture on which to assemble groups and vary their head heights.

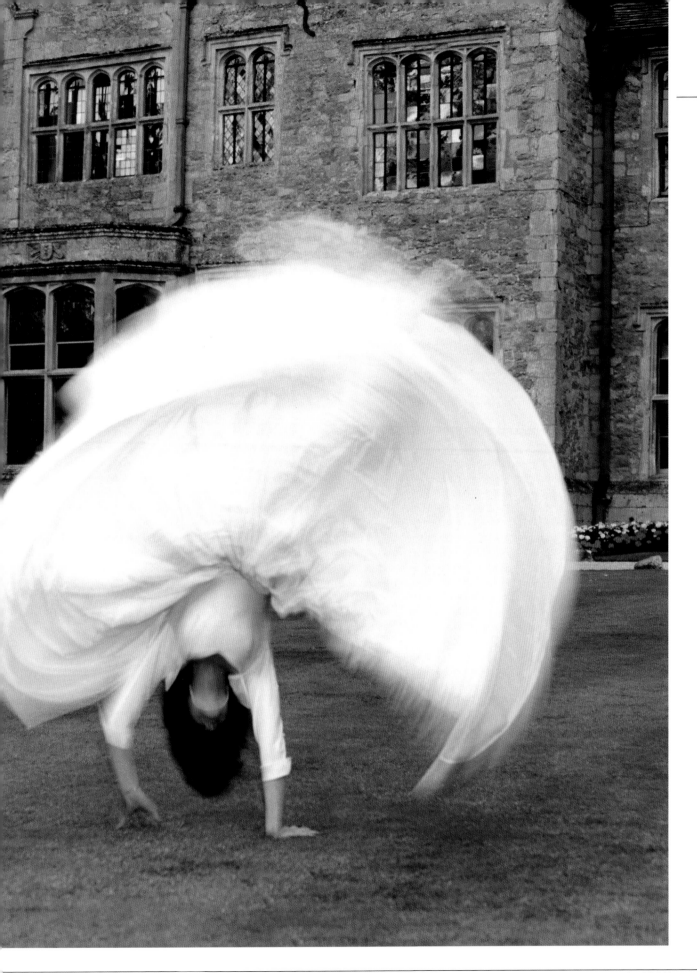

Part 6

AFTER THE WEDDING

The couple will be eager to see a selection of proofs after the wedding, to decide what to include in their album and which images to offer family and friends. You can show these as proof prints, slides, negatives via a video converter or on a computer screen. Whichever method you choose, carefully edit your photographs before presenting them, cropping where necessary to ensure the best possible selection.

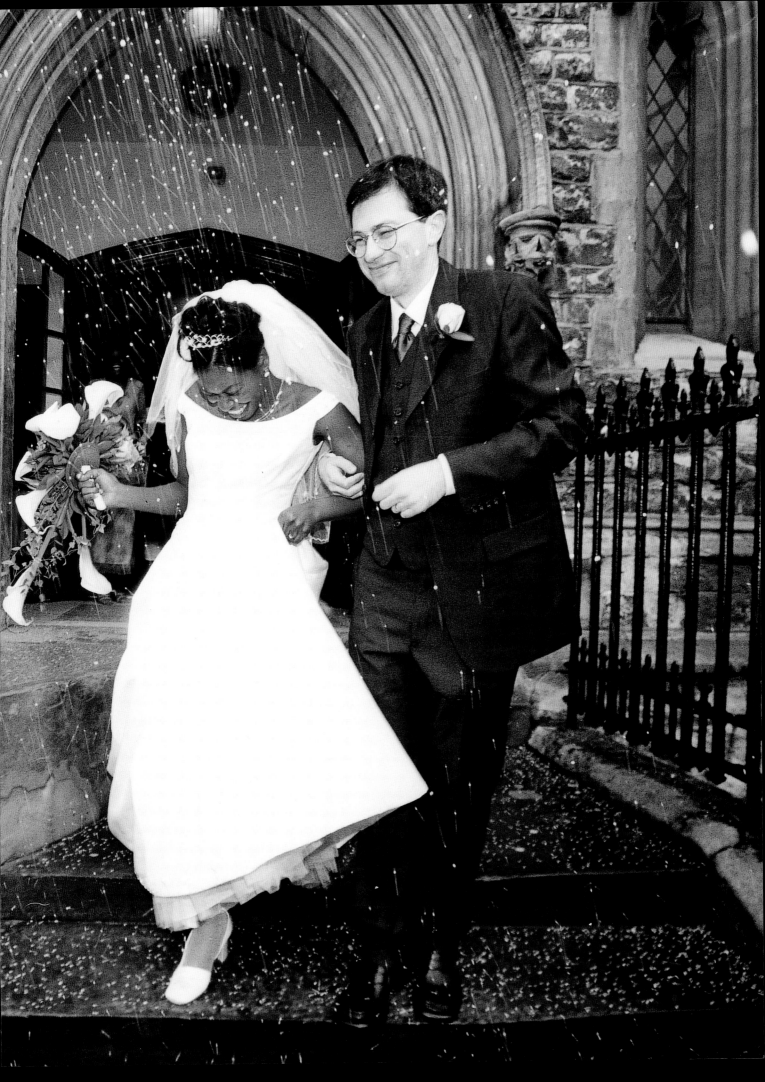

Processing and printing

There can be no excuse for poor-quality prints; they are totally unacceptable, and yet every week prints that are not of the best quality are handed over to clients. Of course, it is unrealistic to think that every print should be handmade – the majority have to be machine made in a commercial laboratory, but there is no reason why they should not be excellent.

The first stage is for the photographer to use the most appropriate film – one made specially for this type of subject – such as Fujifilm NPS 160. The film should be 'fresh' and not have been lying around in the sun for days. All rolls should be from the same batch. Expose the film correctly. Ask the laboratory to check this and tell you if there is anything consistently wrong with your exposure levels. You can remedy the problem of overexposing so long as you know.

Use a reliable professional laboratory that subscribes to a monitoring service. This will ensure that film processing is carried out to prescribed standards.

Do not accept any prints from the laboratory that you consider to be less than 100 per cent. Every lab has the occasional off day and may send out prints that are slightly pale or a touch up on the magenta. If they are not up to standard, send them back. The lab will soon get to know which customers are fussy and endeavour to give them nothing to criticize.

You should know yourself what a good print looks like. All too often the major defect is printing too light so that the picture's details are lost. Printing darker will add density to the highlights, but will not make the mid tones, such as the subjects' flesh, proportionately darker. The overall effect will be much better.

Very often an original set of prints will be excellent, but reprints, while acceptable in their own right, will not match them. If you are making up an album of mixed-size prints from both originals and reprints, they may look incongruous when placed together on the same page. To avoid reprinting problems, send original prints to the laboratory and ask them to match them.

Black and white

It is not easy to get optimum black-and-white images on colour paper. Insist that your laboratory uses black-and-white paper, or change to another that does. Alternatively, you can get a reasonable sepia image on colour paper, although this is not the same as a black-and-white print, sepia-toned. When you receive a set of sepia-tone images on colour paper, check them for consistency, since negative density can sometimes affect the colour of the image.

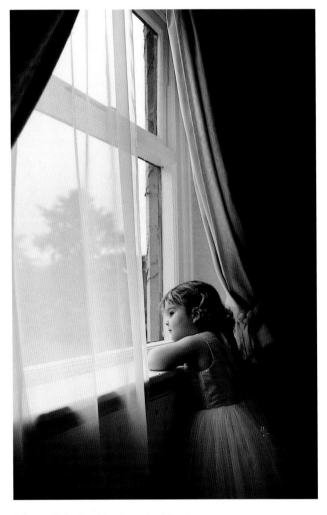

Above: Printing black-and-white images
If your black-and-white images are printed on colour paper, they tend to look better if they are given a warm tone that mimics sepia, than if they are printed to produce a neutral tone.

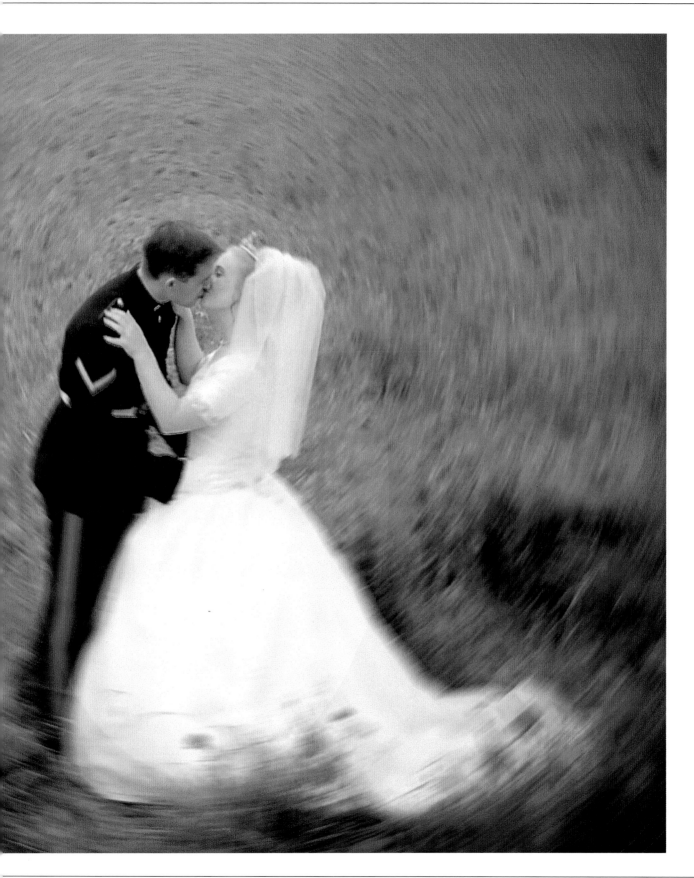

When to use digital images

Film is still the most practical capture device for wedding photographers, but there is no reason why you should not use digital imaging when producing the prints to add a few special touches to the wedding coverage. In an age where print production has shifted from the personal darkroom to the high-tech laboratory, a great attraction of digital imaging is that it enables the individual to add their own touches to an assignment at the production stage, in the same way conventional hand printers shape the final image, but with an even greater opportunity for creativity.

Manipulation and output

Start by scanning your original image. The easiest way to do this is to scan a print, producing a file to the intended finished size at a resolution of 300 pixels per inch. You can then manipulate the image to suit your clients' tastes and to correct any details you may be unhappy with. You can then either send the file to a laboratory for outputting or produce a print yourself.

It is possible to buy inkjet paper with a surface that matches the traditional silver-based papers. Alternatively, some albums have pages made from coated watercolour art paper so you can print directly onto the page, saving the need for separate mounting and creating a very professional presentation.

Use digital imaging to:

- Tidy up an image by removing items that distract the eye with the rubber stamp tool.

- Substitute closed eyes for open by incorporating a similar image of the same person.

- Create customized title pages – at the front of the album and to divide the wedding into chapters.

- Produce distinctive monochromatic images in a much greater variety of colours than can be achieved by conventional toning.

- Create a montage of different images.

- Add borders to your pictures.

- Create fantasy images, limited only by your imagination, that add to the fairytale that is the wedding.

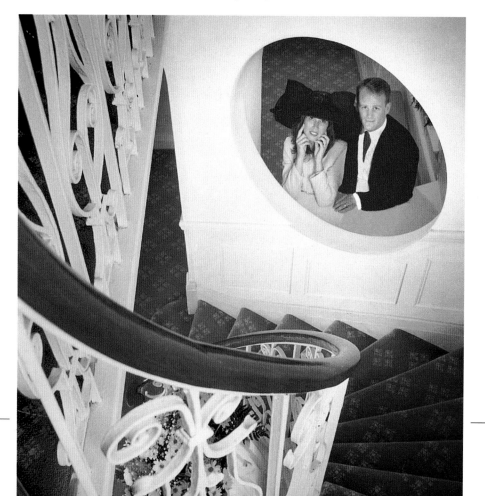

Left: Substitution
The photographer wanted an image of the couple within this circular window, but it was not practical at the time. Instead he produced this photograph digitally, adding the couple into the space on the other side of the window.

Facing page: Partial colour
You can create interesting shots by digitally copying the popular tinted style of hand colouring onto just a few elements in a picture. In this case, the photographer has highlighted the confetti.

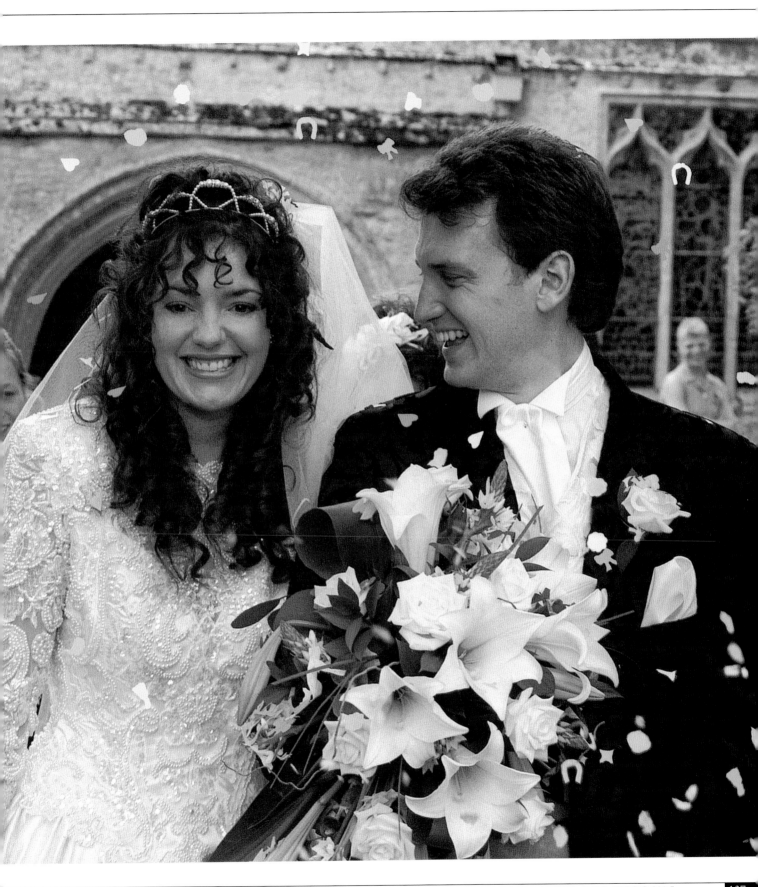

Creative digital imaging

It is very easy when manipulating a print digitally to get carried away with the limitless changes you can make, overlooking what the client would like. Never lose sight of what you have been commissioned to produce – a record of the bride and groom's wedding day, capturing the special moments for all time. As with all technical creativity, the viewer should be admiring the image, not asking how it was done.

Fortunately, with digital work you can easily step back if you go too far. Make sure you save the images as you make your changes, and use Photoshop layers in production. Digital afterwork is far easier to remove than when you have been overzealous with a real airbrush!

Some laboratories are now offering to combine your wedding images with their stock shots. You can order their images from a catalogue, and the results are not dissimilar to the method of double printing popular a few years ago where, for example, an image of the couple was placed in a champagne glass. However, these images are rather banal and go against the very nature of wedding photography, which is all about creating a unique record of the couple's day, with individual images of them and their guests in their own choice of settings.

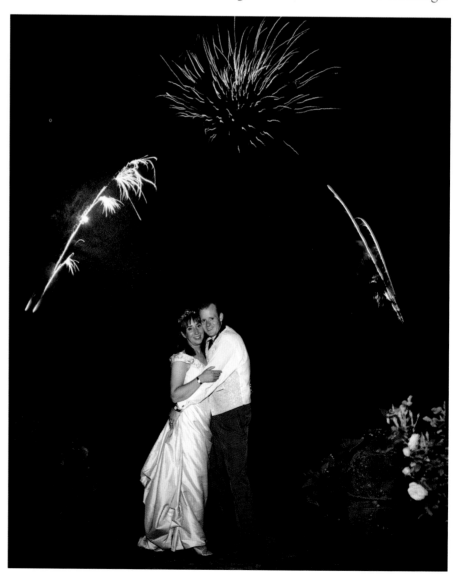

Right: Fireworks in place
It is very difficult to capture fireworks in the background of a portrait because you do not know where they will occur. Here, the fireworks were photographed at the wedding but have been added to the shot of the couple afterwards to create a striking photograph. Cheating? Not at all – creative licence!

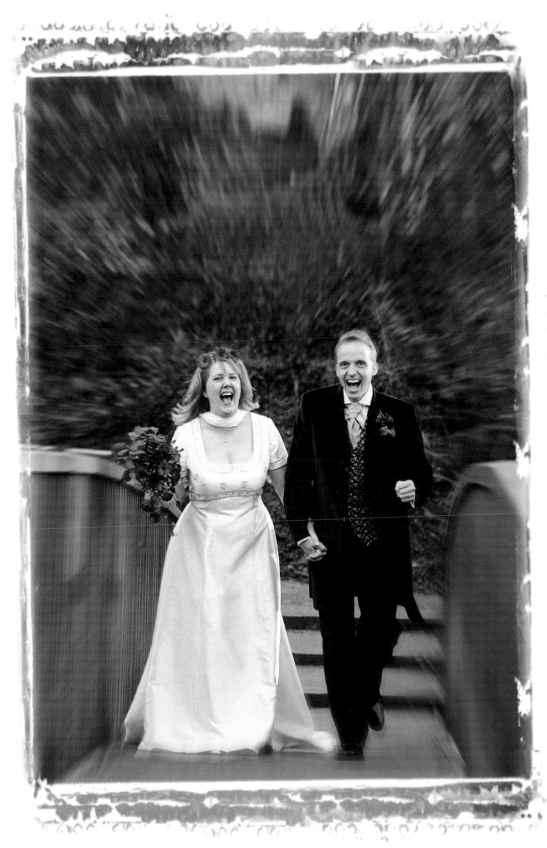

Left: Using tools
The motion blur of
this photograph adds
to the storytelling
and has been combined
with a filter from
Photo/Graphic Edges™
to create a lively
looking image.

Wedding albums

The final home for most wedding photographs is an album. Sometimes people talk about a 'book' instead, but the end result is the same. Many different styles are now available, but a lot of photographers still use an off-white plastic album with brown leaves.

On the one hand, some will argue that the album is just a way of keeping the photographs in some sort of order and so it should be cheap but tasteful. Others are happy to accept that an album made from quality materials, with the photographs presented in an imaginative way, gives you a keepsake that is worth more than the photographs alone, and is therefore worthy of a higher fee.

Black-and-white photography used to be mounted on white leaves. However, early colour prints with degraded whites did not look good on a white background, so deep brown or green leaves were introduced. Nowadays, you can buy them in all colours; not only the leaves but the cover as well.

Placing the prints beneath overlays is the most commonly used system for mounting the photographs as it is quick and easy to do. However, many photographers like to mount the photographs on to the leaves and/or cut special overlays themselves. They also use what are termed underlays, which are mounted between page and print to produce a border about 3mm (⅛in) wide. Individuality is the name of the game. Just one word of warning: do not get too carried away. It is the photographs you want the client to admire, not the mounting.

An album should always be supplied with a title page, giving details of the wedding day, as it could become a family heirloom. Nowadays, it is easy to make the title page yourself, using an inkjet printer. Some album manufacturers supply pages specifically for this purpose, made from coated inkjet paper, but it is easy enough to mount a sheet beneath an overlay. Long-life materials and inks are now becoming available for desktop printers.

Give a presentation

Before you make up the album, the couple has to select the pictures they would like to appear in it. Simply handing over a book of preview photographs does not do justice to your work, nor will it provide your clients with the best possible album. This is where the projection/computer methods score over the traditional. On the screen, you can demonstrate how the photographs are intended to be presented. If you are using prints, have the photographs loose before the couple arrive and show them on the table how particular images placed opposite each other can work well and add to the record of their special day.

Making up the album

This requires care and thought. If the photographs have been selected by the client, you may find two facing each other that are not really compatible. On the other hand, you may be mounting up a number of small shots taken in the church and have one left over. Should you place this on the next page with all the outdoor shots?

The simple answer is no. When there is a page you need to fill, add some of your reportage and detail pictures to broaden the coverage. If necessary, you could add a few prints that will carry the picture story through to the next stage in a logical and natural way.

What about mixing black and white and colour? There are no rules governing this, other than that the result should look good and reflect the happy day as accurately as possible. While each individual photograph you include should be as faultless as you can make it, the whole effect of the album selection must work to make the shots look even better.

Do not forget to include your name and telephone number in the album, and it is a good idea to add the © symbol. People often want reprints, and it is an oversight not to give them your contact details. And if friends viewing the album like it, this is a good way to gain new customers.

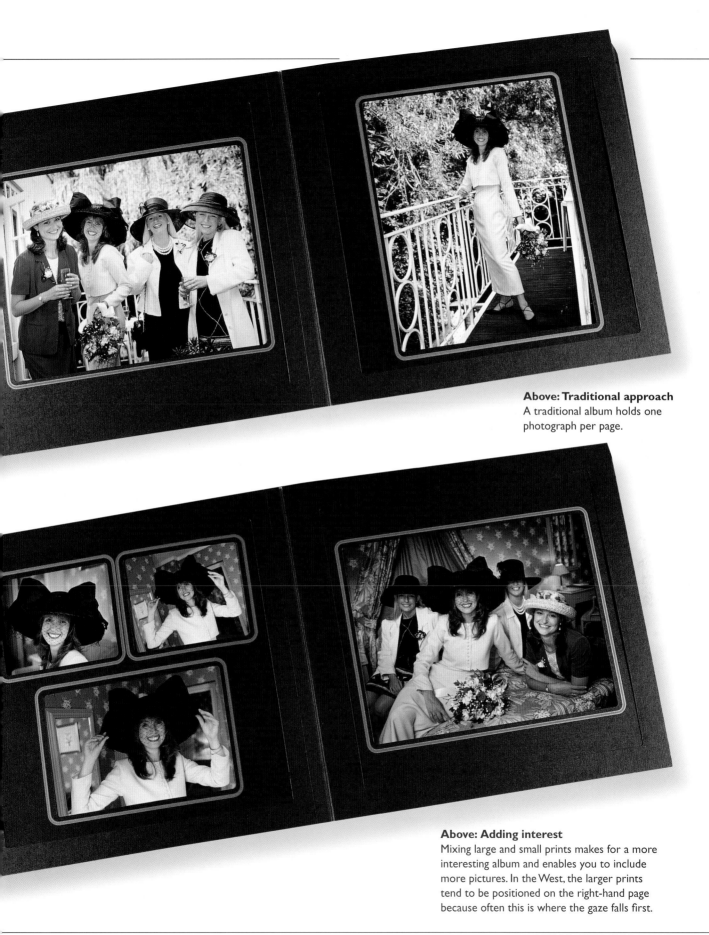

Above: Traditional approach
A traditional album holds one
photograph per page.

Above: Adding interest
Mixing large and small prints makes for a more
interesting album and enables you to include
more pictures. In the West, the larger prints
tend to be positioned on the right-hand page
because often this is where the gaze falls first.

More advanced albums

There are various other ways of enhancing the wedding album. Some photographers consider themselves to be storytellers and create a book of the wedding divided into chapters:

Chapter 1: Pre-wedding informal portraits of the couple, perhaps taken out of doors at a venue special to them.

Chapter 2: The bride at home, getting ready for the ceremony and with her family.

Chapter 3: The bridegroom and his family.

Chapter 4: The ceremony – the arrivals, the formalities.

Chapter 5: Family groups.

Chapter 6: The wedding day portraits of the couple.

Although these 'chapters' may only be a few pages long, it can add to the presentation, and you can create title pages to tie in with each chapter.

Overlays and fold-outs

Presentation can also be made more interesting by cutting overlays so that when you turn the page you

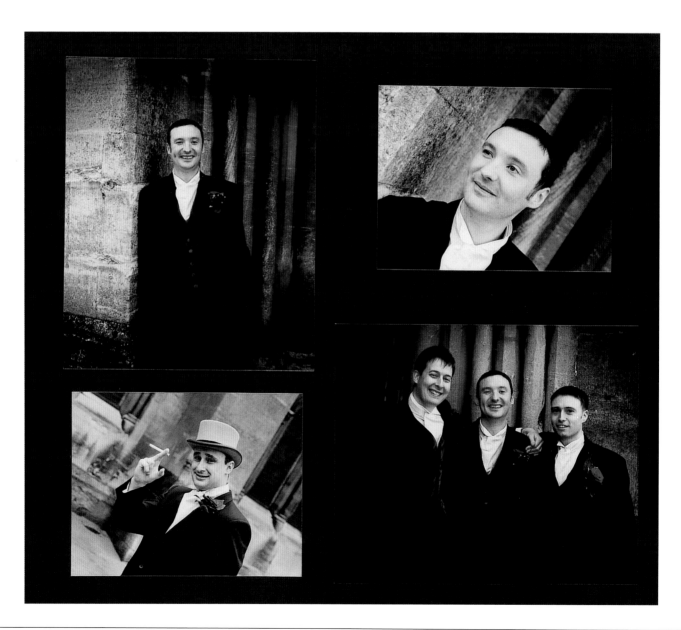

see a small image behind an aperture. When you turn over the leaf you see the larger photograph from which the detail came. Or you can add extending pages, which fold out to show panoramic views or larger images that wouldn't otherwise fit inside the album. Again, don't overdo these features as it can have the negative effect of detracting from the pictures.

In addition to square, rectangular and oval overlays, you can also buy other shapes. Some albums look as if a salesman has unloaded a mass of fancy shapes on an unsuspecting photographer. It is always better to play safe and use only a few of these overlays per album – and if in doubt, stick to rectangles.

The pictures on this page are just a few that won the Guild of Photographers Wedding Photographer of the Year 2000. The judges for this award included not just photographers but brides as well. It is interesting to note that some of the other entries featured fancier presentations, but sometimes the wedding pictures seemed to be of secondary importance to the album.

Facing page: Stuart Bebb's album
All the photographs shown here are from Stuart Bebb's album, which won the Guild of Photographers Wedding Photographer of the Year 2000 title.

Below: Using an aperture
The white page reveals the bridegroom through an aperture, and on turning the page you see the bride as well (below right).

Right: Sepia-toning
A sepia image of the bride with an angular crop.

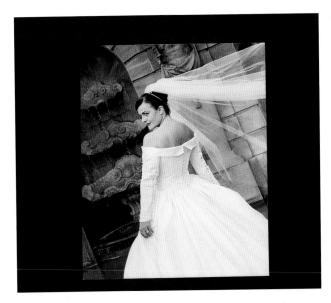

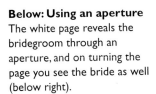

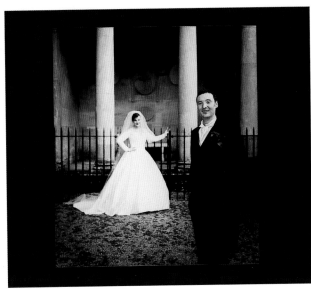

Competitions

All the film manufacturers and various professional organizations organize regular competitions for wedding photographers. It is worth entering examples your work for these for several reasons:

• They enable you to measure your skill against other photographers.

• In addition to the major prizes, there are often many more merits and commendations to be won.

• If you do win you will get plenty of useful publicity, which will help bring you more assignments.

• Your intention to enter will help your photography, because you will probably be thinking about lighting, composition and mood more than usual.

• You will become tuned into competitions and begin looking for published winners. Their images will give you ideas for new pictures of your own and help you to adapt your own ideas into great shots.

It is sometimes said that winning prints are not what the market wants, that they are too sophisticated for most people. It is true that preferences for certain styles in photography, just as in fashion, are slower to reach outlying country districts than they are to be adopted in large towns and cities, but just as the catwalks of Paris and Milan influence what is sold in your high street, award-winning ideas will eventually influence all weddings and how couples want to remember them.

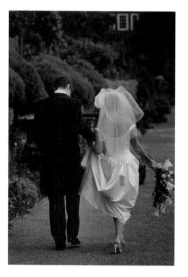

Left: All angles are important
The occasional back view is just as vital a part of the coverage as frontal ones since the bride was the only person never to see herself from that angle. But the shot does not have to be static as this casual picture shows.

Facing page: The art of selection
Selecting the right amount of background is an intuitive skill. You need enough to set the scene but not so much that the eye is distracted away from the bride and groom.

Above: The arrival
The photographer was not to know the bride and her mother were each to speak to a bridesmaid but he was ready for whatever happened. His observation has resulted in the capture of a delightful moment.

Bottom right: Crop close
Everyone loves to see faces. All coverages should have plenty of close-ups of happy friends.

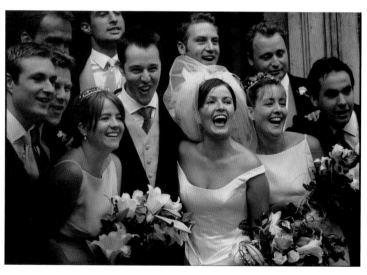

What is certain is that brides everywhere want natural-looking pictures that tell the story of their wedding day. At the same time they should have all the hallmarks of good classic wedding photography.

The 2000 Fujifilm Wedding Photographer of the Year was Keith Thompson, whose portfolio is reproduced here. Note two things that are always a feature of Keith's photographs: firstly, simplicity. Even when the picture is full of fine detail, you do not have to look for the main subject, as the lighting and composition leads you directly to the bride. Second, there are never any distracting elements that vie for attention with the main subject – the bride.

In each of the pictures displayed here, the bride stands out clearly. In the group shot, it is her face that shines out among the others. In the confetti shot, although it is full of people, it is the bride's face we see. And in the shot as she walks away from us with the groom, our eye stays on the bride – there is nothing to draw it away.

These pictures show the bride as she wants to be remembered on her wedding day, and Keith Thompson is a master of his art. There are many other good wedding photographers, those who fully understand what is expected of them and how to take perfect pictures – with careful thought and lots of practice, you too could be one of them.

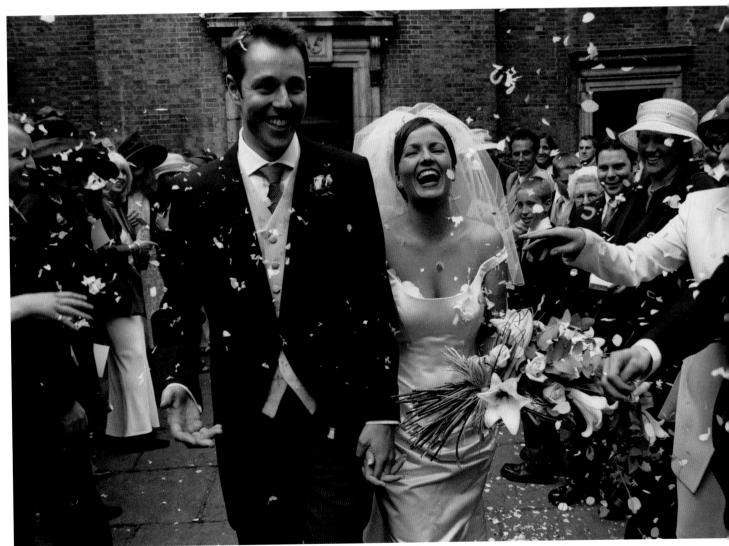

Charging for your work

Most wedding photographers begin by taking pictures for their family and friends and are happy just to be reimbursed for the cost of films and processing. Nothing causes more resentment among established full-time professionals – including many who climbed the same career ladder – than the thought of unfair competition from those who have a secure job and good salary and merely regard wedding photography as a paying hobby.

Photographing a wedding properly involves more than just three hours on a Saturday afternoon; a single wedding can easily occupy ten or twelve hours of your time. When calculating your fee, take into account all the hours worked, from the initial enquiry and sending the brochure, the first meeting, the meeting prior to the wedding, reconnaisance visits to the venue, travel and attendance on the day at up to three venues, preparation of film for laboratory, numbering, editing prints etc., presentation to the client, reorders to lab, mounting prints and making up the album.

Apart from time, materials and laboratory services are also considerable. (Do not think you can get prints cheaper by making them yourself; remember the time it will take.) You should never skimp on film nor choose the cheapest processing services. It is better to take too many pictures than too few, but each extra film you load costs not only for that roll itself, but for processing as well – bear this in mind when charging for your work.

Photographers in the past used to work on the principle of appearing to take the photographs for nothing, and then covering all their costs and making their profit on the sale of prints afterwards. This is a bad precept on two counts: one, you may not sell many reprints, and two, it gives the wrong message to the customers. The taking of the photographs is the really skilled work. They should realize they are paying for your skill and expertise – do not give it away.

There are numerous ways of charging, but the most popular are two variations of the same basic principle.

The first is to quote a package price that includes your photography and a certain number of prints of the clients' choice in an album. Many photographers use this because they think the customers prefer it, and by quoting a few pounds less than their competitor they will obtain most of the business. However, the second variation is to charge a prepaid minimum fee and tell the clients that it is up to them how they spend it. This gives the clients a lot more choice, and the photographer greater opportunity to sell more.

The fee has to cover your time at so much an hour, but only charge your time on the wedding day itself, incorporating all other work mentioned above. The fee includes prints and an album, but the quantity and size is entirely up to the clients. They do not have to stay with the minimum purchase – they can have more of your time (which is the first item to be taken off the deposited fee), more prints than they anticipated (because you have taken so many good ones), and should choose the actual album only when they have selected the photographs. This way, you will generally find people spending more with you than if they had booked a fixed package, but all this without your doing any hard sell. Good photography, well presented, sells itself. Just make the charging system very easy for all to understand. Do not talk about prices but fees. Remember that the public are used to paying other professionals by the hour whether these are plumbers, garages, lawyers or accountants. It is up to you to decide in which charging bracket you belong. The following is only a guide, but illustrates how simple your fee structure can be.

A sample guide to fees

There is a minimum charge for the wedding coverage which encompasses three elements: the photographer's time, the prints and the album. The customer decides how to spend their money. The minimum fee, payable before the wedding is £/$A. From this the time spent

on the wedding will be deducted leaving the balance for prints and the album.

Time is charged at £/$B per hour while the photographer is at the wedding

Prints are charged as follows:

	Small	£/$C
	Medium	£/$D
	Large	£/$E
	2 page panoramic	£/$F
Albums	Standard	£/$G
	De Luxe	£/$H
	Special	£/$I

Travelling time and expenses should be charged for weddings more than a set number of miles from the studio.

Some hints for charging

Charge prints at the same price whether sold loose in mounts or included in the album. Do not refer to prints in exact dimensions as some images are best square, others trimmed to a long, thin format. If you want to mention size, stick with one dimension only, e.g. 254mm (10in) prints, giving you the opportunity to crop without leaving yourself open to misunderstandings. Encourage them to order their prints promptly by offering special bonuses, e.g. a free enlarged print for orders of a certain value received within one month. Use prints and not discounts as your bonuses as they have a greater perceived value. Also if brides are aware they are paying you by the hour they are more likely to be ready on time!

Wedding photography is not a seven-day-a-week occupation, so most wedding photographers do other work as well. Some are professional photographers working in portraiture, industry, advertising, laboratories, etc., while others have an occupation outside photography. This does not necessarily mean they are less talented – in wedding photography, people skills are as important as technical prowess. What is important is that you should be experienced and photographing weddings regularly so you can undertake all the technical, posing and lighting aspects without having to think too much about them. This enables you to concentrate completely on the people and their expressions, and only then will you be in a position to command really good fees for your work.

Gaining experience

Wedding photography cannot be practised. You can rehearse posing a couple together – and you should do this – but you cannot emulate the pressure of the occasion, the shortage of time and working in foul weather. There are three ways of gaining experience:

1 Accompany another photographer as an observer. Do not take photographs, simply absorb the atmosphere and watch how he or she handles every situation as it develops. It is a good idea to do this in a district away from your own, so the photographer does not feel threatened by a would-be competitor. In the UK, The Guild of Photographers has an organized scheme for this.

2 Work for a year or two for a large firm that employs photographers for weddings. It is very good discipline, as these companies have exacting standards and demand a consistent style from all their operators. They will require evidence of your ability before they take you on for training.

3 Work as a trainee wedding photographer for couples on a budget. Advertise by placing a card in wedding shops, offering your services for the cost of the prints only, with no minimum order. On the day, do the very best job you can and take plenty of shots. This will be good practice and also provide sample photographs to show prospective clients. Make sure the couple understand why you are doing this and that it is not a scam. They must also accept that should you fail in any way, they cannot sue you.

Copyright, ownership and insurance

Whether you are photographing one wedding for a colleague or planning to set up your own wedding photography business, you need to know your position regarding copyright and ownership of the negatives and to inform your clients beforehand so that there are no misunderstandings.

To obtain further information on these matters, it might perhaps be wise to consult a legal adviser on your own particular circumstances.

Negatives

In the absence of any contrary agreement, through general law, in most countries the negatives belong to the owner of the film (i.e. usually the photographer). The film owner is not obliged to hand them over to the clients, but is required to retain them in good condition for a reasonable period, to allow the client time to order reprints. If photographs are being taken by an assistant, the negatives will belong to the studio employing him, which purchased the film.

Copyright

Again, unless otherwise agreed the copyright of the photographs belongs to the photographer and not the client. In the case of a photographer engaged casually to photograph weddings for a studio, he is effectively self-employed, and is not employed under a 'contract of service'. The copyright would therefore belong to him as the 'first owner'. To counteract this, the studio owner should draw up an agreement assigning copyright of all photographs taken for and on behalf of the studio to the 'photographer's employer'.

It is an offence for anyone who is not the owner of the copyright to copy by any means whatsoever, or to engage any third party to copy, an image. This means that clients should not copy their wedding photographs with either a still camera or a video camera, nor should they scan them into their computer for emailing to their friends overseas.

A notice to this effect should be placed prominently on your literature and displayed in your premises, and it should also be a clause in your booking contract. Each and every photograph should be marked on the back with the international copyright sign © followed by the photographer's name.

A client's right to privacy

Although the photographer owns the negatives and copyright, and the clients are not permitted to reproduce them without permission, there are also certain restrictions on what the photographer can do with the photographs.

Pictures commissioned for private and domestic purposes may not be exhibited or shown in public in any form without the consent of the person who commissioned them. The client's permission must be obtained in writing and may be withdrawn at any time.

You may wish to submit a wedding photograph for a competition or publication, display it in an exhibition or perhaps show it on your web page. In this case it is good practice to include a clause to this effect somewhere on your booking form, and have every client sign acceptance when they book. Very rarely will any client refuse, but having such an agreement in writing could save you much trouble in the future.

The above should cover you in most cases, but using photographs in advertising, i.e. commercial use, raises new issues, particularly in the USA, where the client would be liable for a fee. If there is a possibility that you might want to use photographs for this purpose, state in the contract that any images used in a commercial (as opposed to a promotional) manner will involve negotiation of fees for such use.

Safeguarding your own position

From time to time clients claim that they 'understood they got the negatives included'. It is important to

make your position clear from the start so that there are no such misunderstandings. With the advent of digital imaging, similar claims will be made with regard to files. Now that facsimile copies can be made cheaply from prints many clients will be tempted to make their own copies despite knowing that it is illegal, just as they copy CDs, computer applications and so. The photographer will be left totally unaware of this copying and even if he finds out, will be reluctant to seek damages through the courts. Therefore it is crucial that photographers charge properly for their original work, which is the creative part, and supply reprints at a modest cost.

To safeguard your position at least until the major transaction is completed it is essential that you:

❶ Obtain the basic fee upfront before the wedding. (Afterwards you will find that your clients will have gone over their budget on the wedding and overspent on the honeymoon.)

❷ If allowing them to take proof prints home, make sure they are overstamped COPYRIGHT in indelible ink. (You can later remove this with a proprietorial solvent).

❸ If on a CD or downloaded by the internet use only low-resolution images.

Insurance

It is assumed that you will already have insurance cover for loss of or damage to your equipment, and motor insurance for your vehicle. However, once you start to photograph weddings it is important that you also obtain two other types of insurance: public liability and professional indemnity.

Once a client has booked you for a wedding, you are obliged to deliver the agreed photography. If you are unable to supply, it is no defence to simply say that your car broke down, your film got lost in the post, your camera had a fault you were unaware of, or the laboratory damaged your negatives. In the past, clients would have shrugged their shoulders and gone away. Not any more – we live in an age of litigation. From all sides clients are encouraged to sue suppliers who do not meet expectations. While insurance cover can be obtained through local insurance brokers, it might be better to obtain your cover through specialist trade sources, who may be able to offer you better rates.

Public liability insurance or on-location liability Insurance

This covers you for liability for damage or injury to members of the public. Suppose a wedding guest falls over your camera case, breaks a leg and is off work for months. You could be held responsible for the accident and be bankrupted by the size of the claim. The minimum cover for this type of insurance should be at least £/$1,000,000.

Professional indemnity insurance or errors and omissions insurance

This is to cover any failure to fulfil contractual obligations, whether as a result of negligence or matters beyond your control. If wedding photographs are lost you may have to pay in order to reconvene the wedding party, some of whom may have flown thousands of miles. Then there are all the additional costs: the rehiring of clothes and vehicles, the hotel, fresh flowers and a new cake.

Taxation

Remember that when you start charging fees for wedding photography you immediately become liable for income tax. Keep complete records of all your expenditure and receipts, and seek professional assistance from an accountant.

Sample booking form

Note this form is only a guide. You should discuss your own contract with your lawyer. Additional advice can be obtained from the organizations on page 141.

Booking Form

Date of Wedding _____

Address of Ceremony _____

Name of Bride _____

Address _____

Home telephone _____

Work/mobile telephone _____

Address bride will be leaving from prior to ceremony (if different from above) _____

Number of guests _____

Time of Ceremony _____

Address of Reception _____

Name of Bridegroom _____

Address _____

Home telephone _____

Work/mobile telephone _____

Address of bride and bridegroom after the wedding _____

Dress: Morning/Lounge/Evening Suits

Type or name of the photography coverage selected _____

Photographer's fee for selected service

- This includes the photographer's attendance for _____ hours, professional services taking photographs, showing the originals by (previews/transproofs/video/email) and supplying _____ photographs
- Additional hours as requested @ xx per hour
- Travelling time/expenses above basic included amount
- Album selected

£/$ _____

£/$ _____

£/$ _____

£/$ _____

Total £/$ _____

Less deposit payable on booking £/$ _____

Balance (due 30 days before wedding) £/$ _____

Confirm? YES/NO

Pre-wedding consultation: Day and date _____ Time _____

Received the sum of £/$ _____ being the booking fee for the above wedding

Date _____

Photographer's Signature _____

Please read the terms and conditions below before signing

I hereby confirm the above booking for wedding photography and have read and agree to the following terms:

1. Copyright in the photographs belongs to the photographer and the client may not reproduce any image or authorize reproduction by any means whatsoever including photographing with a still or video camera, scanning into a computer or any form of photocopying. Any such copying is unlawful and may be a criminal offence.

2. All original images whether on film or electronic medium belong to the photographer. As the person(s) commissioning the photography I/we hereby agree that the photographer may publish or exhibit the photographs or enter them for competition, but not use them in any commercial (i.e. advertising) manner without further authorization.

Date _____

Signature _____

Where to get further advice

If you plan to take wedding photography seriously, it is a good idea to join a specialist organization that caters for both full-time and part-time wedding photographers. You learn a lot from them and also get the opportunity to meet with other wedding colleagues. The following both publish material monthly in addition to holding special events and competitions for wedding photographers. Both welcome members from around the world. They also offer specialist insurance services for photographers.

The Guild of Wedding Photographers UK
22 Greenwood Street, Carlton Place,
Altrincham, Cheshire, WA14 1RZ, England
Tel: 0161-926 9367
Fax: 0161-926 9367
www.gwp-uk.co.uk

Wedding and Portrait Photographers International
P.O.Box 2003, 1312 Lincoln Boulevard,
Santa Monica, CA 90406-2003, USA
Tel: (310) 451-0090
Fax: (310) 395-9058
www.wppinow.com

The following associations provide training courses:

British Institute of Professional Photography
Fox Talbot House
2 Amwell End
Ware
Herts, SG12 9HN
Tel: 01920 464011
Fax: 01920 487056
Email: bipp@compuserve.com
www.bipp.com

Professional Photographers of America, Inc.
229 Peachtree Street NE
Suite 2200
Atlanta
GA 30303
USA
Tel: 800 786 6277/404 876 6277
Fax: 404 614 6400
Email: csc@ppa.com
www.ppa.com

Equipment
• Pro-4 filter systems are available from distributors in most countries. Information: www.pro4.com
Bare bulb flash units are made by the following manufacturers (among others) and available from professional dealers:
Bowens, Lumedyne, Norman, Sunpack

• Brackets for holding a flashgun directly above the lens are available from dealers (Stroboframe), and Pro-4 (Justrite), see above.

• Very light, portable reflectors/diffusers are available through dealers from Calumet, Lastolite (UK), and Westcott (USA).

• FX File negatives for sandwiching with negatives when printing are available from www.bellwood.co.uk.

• If you feel tempted to use a digital camera the Fujifilm FinePix SI Pro Professional SLR can be recommended. Based upon a Nikon F60 35mm camera it accepts most Nikon lenses. Its pictures have a real film look and produce very good colour.

Index

Acknowledgements

Over many years as a wedding photographer I have benefited enormously from the generosity of leading wedding photographers in the UK and the USA who have shared their skill and expertise, and in presenting this book I am pleased to continue this process to others.

In particular I thank Roy Doorbar, with whom I have collaborated for over thirty years and with whom I founded The Guild of Wedding Photographers UK in 1988 along with our wives, Rosemary and Jo, with a view to improving both the skills and the status of wedding photographers everywhere. The Guild's qualification, Craftsman in Wedding Photography, is highly regarded, and I am indebted to the many craftsmen who have kindly supplied most of the illustrations in this book. My thanks are also due to Graham Rutherford and his staff at Fujifilm UK for their continuing support.

My gratitude goes also to all the brides and grooms, their families and friends, without whose weddings none of these pictures would have been possible.

Finally, thanks to Sarah Hoggett, who commissioned this book, Emma Baxter, the in-house editor, Roger Daniels, the designer, and all those at Collins and Brown whose many different skills have brought this book to fruition.

Ian Gee

Picture credits

The following photographers kindly supplied images for this book: (T=top, B=bottom, R=right, L=left)

Jeffrey Ascough: 18, 52, 59(T), 96(B), 120, 123. Andrea Barrett: 31, 79, 111(B). Stuart Bebb: 107, 117, 125, 127, 128, 129, 132, 133. Andrew Colley: 43(R), 77. Roy Doorbar: Main cover image, 17, 22–3, 24–5, 26, 30, 41, 46, 51(B), 56, 64(B), 65, 67, 69(T), 71, 73(B), 86, 111(T). Karen Goodwin: 85(B). Tina Hadley: 20–1, 29, 64(T), 70, 74(BL). Nigel Harper: Cover(TL, back), i, 34(R), 36–7, 39, 44, 51(T), 53, 57, 63(R), 68(T), 76, 88, 89(B), 95, 98(L), 102, 108–9, 114(T), 115(L&R), 116(T), 126, 131. Sarah Hill: 11. Denis Hyland: 17(R), 38, 42, 116(B). Gary Hynes: 12, 62, 78(B), 83, 87(TR). Eileen Mason: 8–9, 27, 63(B), 72, 103, 112(T). David Moore: 19. Suzanne Moore: 10. David Oliver: 98, 99(T), 100, 104(L). Dennis Orchard: Cover, (back 2 & 4), 15, 35, 49, 49, 50, 59(B), 65, 74–5(T), 80, 82(B), 87(B), 94(BL), 97(T), 113. Mo Peerbacus: 16, 32(B), 33, 40, 47(B), 48, 66, 78(T), 81(B), 84, 87(L), 112(B). Powerstock Zefa: v. Stephen Pugh: 29(B), 43(L), 58, 68(B), 94(T). Peter Sefton: 121. Kent and Sarah Smith: ii, 54, 55. Jos Sprangers: 14, 34(L), 101. Tony Stone Images: Andrea Boorhar 63(TL), 114(B), Stewart Cohen 71(B), Erica Lanser 106(B), Bob Thomas 45, Zigy Kaluzny 44(B), Kaluzny/Thatcher 85(T). Steve Tarling: 7, 13(B), 32, 43(T), 47(B), 69(B), 89(T), 90, 91, 92, 93, 122(T). Raymond Thomas: vi, 104. Keith Thompson: 134–5. Gary Williams: 82(T). Les Woodhams: Cover (back 3), 60–1, 81(T), 92(B), 104, 122(B). Wymondham Photographic: 13(T)

If you would like to contact any of the photographers whose work has featured in this book, please contact The Guild of Wedding Photographers UK (see contact details on page 141).